The solution
is in
the problem..

Thames & Hudson

FORMULAS

FOR NOW

formulated by Hans Ulrich Obrist

48 color + 57 b/w = 105 illustrations

$$y=ab^x$$

a $(0,a)$

This book is dedicated to the memory of Július Koller (1939–2007)
and Karlheinz Stockhausen (1928–2007)

Hans Ulrich Obrist and the publisher thank all of the contributors
for their generous contributions and kind assistance
in the preparation of this book.

A formula to measure the weight of this book (W)

$$W = (h \times w \times pp/2 \times P) + (2(h \times w \times 2) \times E) + (2(h \times w) \times C) + (2(h \times w) \times B)$$

h = height of page in metres
w = width of page in metres
pp = number of pages in book
P = weight of paper (165gsm)
E = weight of endpapers (140gsm)
C = weight of printed laminate cover (140gsm)
B = weight of board (2,000gsm)

Formula/page 1 = Peter Saville
Formula/this page = John Brockman
Formula/pages 12–13 = Pedro Reyes

First published in 2008 in hardcover in the United States of America by
Thames & Hudson Inc., 500 Fifth Avenue, New York, New York 10110

thamesandhudsonusa.com

Library of Congress Catalog Card Number 2007905835

ISBN 978-0-500-23850-9

Printed and bound in China by Everbest Printing Co. Ltd.

contents

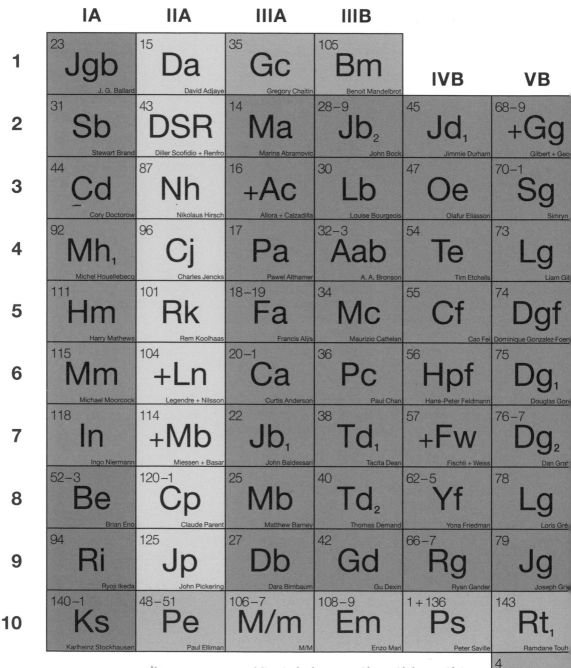

	IA	IIA	IIIA	IIIB	IVB	VB
1	23 **Jgb** J. G. Ballard	15 **Da** David Adjaye	35 **Gc** Gregory Chaitin	105 **Bm** Benoit Mandelbrot		
2	31 **Sb** Stewart Brand	43 **DSR** Diller Scofidio + Renfro	14 **Ma** Marina Abramovic	28–9 **Jb₂** John Bock	45 **Jd₁** Jimmie Durham	68–9 **+Gg** Gilbert + Geo
3	44 **Cd** Cory Doctorow	87 **Nh** Nikolaus Hirsch	16 **+Ac** Allora + Calzadilla	30 **Lb** Louise Bourgeois	47 **Oe** Olafur Eliasson	70–1 **Sg** Simryn
4	92 **Mh₁** Michel Houellebecq	96 **Cj** Charles Jencks	17 **Pa** Pawel Althamer	32–3 **Aab** A. A. Bronson	54 **Te** Tim Etchells	73 **Lg** Liam Gil
5	111 **Hm** Harry Mathews	101 **Rk** Rem Koolhaas	18–19 **Fa** Francis Alÿs	34 **Mc** Maurizio Cattelan	55 **Cf** Cao Fei	74 **Dgf** Dominique Gonzalez-Foer
6	115 **Mm** Michael Moorcock	104 **+Ln** Legendre + Nilsson	20–1 **Ca** Curtis Anderson	36 **Pc** Paul Chan	56 **Hpf** Hans-Peter Feldmann	75 **Dg₁** Douglas Gor
7	118 **In** Ingo Niermann	114 **+Mb** Miessen + Basar	22 **Jb₁** John Baldessari	38 **Td₁** Tacita Dean	57 **+Fw** Fischli + Weiss	76–7 **Dg₂** Dan Grah
8	52–3 **Be** Brian Eno	120–1 **Cp** Claude Parent	25 **Mb** Matthew Barney	40 **Td₂** Thomas Demand	62–5 **Yf** Yona Friedman	78 **Lg** Loris Gré
9	94 **Ri** Ryoji Ikeda	125 **Jp** John Pickering	27 **Db** Dara Birnbaum	42 **Gd** Gu Dexin	66–7 **Rg** Ryan Gander	79 **Jg** Joseph Gri
10	140–1 **Ks** Karlheinz Stockhausen	48–51 **Pe** Paul Elliman	106–7 **M/m** M/M	108–9 **Em** Enzo Mari	1 + 136 **Ps** Peter Saville	143 **Rt₁** Ramdane Touh

writer composer architect **designer mathematician artist**
psychotherapist scientist **agent** engineer **actor** dancer
gallery **director theorist** sociologist

4 **Jb₃** John Brockr

24 **Ap** Adam Phillips	26 **Sbc** Simon Baron-Cohen	——— **VII** ———			37 **Rd** Richard Dawkins
0 **Rh$_1$** Richard Hamilton	98 **Mj** Michael Joo	119 **Yo** Yoko Ono	133 **As** Anri Sala	**IB**	41 **Dd** David Deutsch
2–3 **Cmh** Carl Michael von Hausswolf	100 **Jk$_1$** Koo Jeong-A	122 **Pp** Philippe Parreno	134–5 **Ts** Tomas Saraceno	150–1 **Aw** Ai Weiwei	46 **Fd** Freeman Dyson
4 **Fh** Florian Hecker	99 **Jk$_2$** Július Koller	126–7 **Hyp** Huang Yong Ping	138 **Js** Josh Smith	152 **Lw** Lawrence Weiner	60–1 **Jf** Jacque Fresco
5 **Sh** Susan Hefuna	102–3 **Jk$_3$** Jeff Koons	128 **Rmc** Raqs Media Collective	139 **Ns** Nancy Spero	153 **Rw** Richard Wentworth	81 **Mh$_2$** Marc Hauser
6 **Rh$_2$** Roger Hiorns	110 **Dm** Daria Martin	12–13 + 129 **Pr** Pedro Reyes	145 **Rt$_2$** Rosemarie Trockel	154 **Fw** Franz West	90 **Ah** Albert Hofmann
9 **Dh** Damien Hirst	112 **Gm** Gustav Metzger	130 **Gr** Gerhard Richter	146 **Kt** Keith Tyson	155 **Sw** Stephen Willats	137 **Gs** Gino Segre
1 **Ch** Carsten Höller	113 **M** Meuser	131 **Mr$_1$** Matthew Ronay	147 **Bv** Bernar Venet	156 **Jw$_1$** Jordan Wolfson	149 **Jw$_2$** James Watson
3 **Ph** Pierre Huyghe	116–17 **+RSn** Rivane + Sérgio Neuenschwander	132 **Mr$_2$** Martha Rosler	97 **Wj** Wang Jianwei	157 **My** Mario Ybarra, Jr.	158–9 **Az** Anton Zeilinger

4 **Cb** Cecil Balmond	39 **Jd$_2$** Jamel Debbouze	58–9 **Sf** Simone Forti	123 **Jpj** Julia Peyton-Jones	142 **Ls** Linda Stone	148 **Iw** Immanuel Wallerstein

introduction

The *Formulas for Now* project began in Spring 2006, when I asked a number of artists, writers, architects, mathematicians and scientists each to contribute an equation for the twenty-first century. Beyond this simple guideline, I gave them no further instructions. Although the invited contributors were permitted to complement their submission with a brief text, the endeavour's success resided in its elegant simplicity: the crystallization of a potentially complex idea into a single equation. It constituted a familiar task for some of the participants, yet it was also—and intentionally so—a provocation for the majority of those who were typically occupied in the production of texts, images and tangible structures. In the end though, all would be bound by the rules of the game.

The project was inspired by Roger Penrose's *Roads to Reality: A Complete Guide to the Laws of the Universe*, published in 2004. This 1,100-page tome is striking not only for its far-reaching scientific arguments, but also for the intricate drawings that Penrose utilizes to illustrate his dense concepts—a brilliant example of *theory-into-form*. Another trigger for *Formulas for Now* was an interview I conducted with Albert Hofmann, the inventor of LSD. At the end of our conversation, he drew the LSD equation on a piece of paper. The power and utter simplicity of this notational gesture struck me immediately and it seemed an interesting point of departure for an undertaking of my own. The result is a kind of intellectual *flânerie* that has grown out of coincidence, chance and resolve, and through the earnest efforts of those who have participated, to each of whom I offer my deepest thanks. It provides unique insight into the working methods and mere curiosities of these individuals and is testament to the vital

role that formulas play in contemporary culture. In the end it asks a very fundamental question of us all: What is your formula for now?

My connection with science goes back fifteen years. In 1993, I was invited by Christa Maar to participate in some of the Burda Academy of the Third Millennium's programmes. The Academy, based in Munich, operates as an international platform for experts of all disciplines, such as scientists, thinkers and visionaries from the fields of business, politics, the arts and the media. In conferences, symposiums, lectures and publications, these individuals are brought together to discuss central questions of today and the future. When I moved to Paris later that year to begin my curatorship at ARC/Musée d'Art Moderne de la Ville de Paris, I began accompanying eminent scientists to exhibitions. I was fascinated by their insights into the work on show, and I set about developing a more sophisticated dialogue between art and science. Since then I have organized or have been involved with several such projects, including exhibitions, seminars and think tanks. To give just one example, 'Laboratorium' was an exhibition I co-curated with Barbara Vanderlinden in Antwerp in 1999. It took the meaning of the 'laboratory' as its subject and explored the relationship between the artist's studio and the scientist's lab. It also included a series of tabletop experiments orchestrated by Bruno Latour.

In concert with such transdisciplinary efforts, I also developed an almost obsessive interest in compiling lists. 'Do It', which began in 1993, offers an excellent example. The project asked how an exhibition might exist merely as a set of instructions and, consistent with Fluxus game-play

of the 1960s, called on artists to offer propositions for the creation of art works. Hundreds upon hundreds of these have since been produced, and the project has migrated organically over the Internet and into more than forty locations, from museums to schools. It is an exercise in dynamic knowledge production that is positioned, through its lightness, flexibility and unpredictability, as an alternative to the stereotypical global blockbuster exhibition. My fascination with lists also features prominently in the interviews I conduct with thinkers of all kinds. My final question is always the same. It concerns the interviewee's unrealized projects –things they have never been able, but aspire, to produce.

If activities such as these succeed in familiarizing audiences with the expansive, even absurd, thoughts occupying some of our greatest minds, they have fulfilled their basic charge. It is my ultimate hope, however, that they inspire new forms of cultural dialogue and can perhaps even serve as a template for related ventures to come.

The *Formulas* project began with such ambitions, and this book is just one of its physical outcomes. In October 2007, Julia Peyton-Jones, Olafur Eliasson and I, in collaboration with John Brockman, Israel Rosenfield and Luc Steels, hosted a series of day-long experiments in that year's Serpentine Gallery Pavilion, designed by Eliasson and Kjetil Thorsen. This 'experimental marathon', curated with Eliasson, heralded the redirection of formulas and equations into live and unpredictable scientific events. Some of the equations proposed had already surfaced on Brockman's website, where he appealed to the scientists and thinkers of

his Edge community to answer the question, 'What is your formula?'—further evidence that the combination of art and science can migrate into exciting new territory.

Different proof of this migration is evident in the physical toll the project has taken on my working life. For what commenced as a naïve curiosity soon cycled back in the form of equations on faxes, email print-outs and formal letters, first into my mailbox and eventually onto the walls and tables of my office. Indeed, after about twelve months of wildly organic growth, the entire workspace was consumed with these formulas, which streamed in more voluminously than I had ever imagined or, frankly, intended. Thus it is with great pleasure that I present them here to you and may, at last, clean my office and restore a modicum of sanity to my daily practice. Enjoy. And as Douglas Gordon says, it has only just begun...

You'll FIND THE FORMULA, AS LONG
YOU KEEP YOUR MIND FRESH!

the formulas

Marina Abramovic

My SECret FoRmulA On How to bEcOme A genius

1 tablespoon of talent
5 drops of popularity
1 drop of luck
10 kilograms of discipline
6 glasses of self-sacrifice
3 grams of spirituality

Mix all the ingredients and leave them over night to cool down.

Drink the substance early in the morning

when the sun is rising and facing East

David Adjaye

Cause / effect x engagement = Public life

2000

15

Jennifer Allora + Guillermo Calzadilla Man Animal Diamond

Pawel Althamer

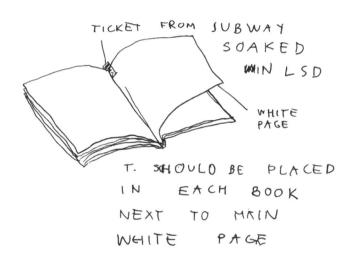

TICKET FROM SUBWAY SOAKED WIN LSD

WHITE PAGE

T. SHOULD BE PLACED IN EACH BOOK NEXT TO MAIN WHITE PAGE

AN EXAMPLE OF T. TICKET

Francis Alÿs

CURRICULUM

VITAE

Curtis Anderson

In 1985 I had an exhibition in a former dentist's surgery in Amsterdam, a gallery known in the art world as 'De Praktijk'. For the invitation card, I created a palimpsest of images centred on my artistic signature, a sphere and cone created by the rotation of my two initials, 'c' and 'a' – a false keyhole, an impossible balance, and so on. A horizontal mark between these two forms alludes to my astrological sign, Libra, and proposes that one compare two bodies of work created under the influence of the drugs LSD and Lithium, both represented on the card by their respective chemical formulas and by exemplary single drawings from my own hand. The whole show was sold as a portfolio of ten images to a private collection in Basel, a fitting place for a story beginning with Albert Hoffmann's 'Sorgenkind'.

I see my work as a defence against the tyranny of known objects in the world. This function was never more true than at the end of an acid trip in 1983. With undoubting clarity, my discomfort gave me the courage to return to an inventive form of drawing after a hiatus of several years.

The Lithium drawings were produced during a stay in the Payne Whitney psychiatric hospital in New York in 1985. They are dark in tone, done in a period of doubt and confusion.

The chemical cocktail that we call life continues to unfold for me in a 'Danse Bipolaire'.

John Baldessari

ARTIST (FORMULA):

$$ART = LIFE (\mp MONEY) \times PASSION \rightarrow$$

$$EXPERIENCE \parallel YEARS \div LOVE$$

$$(\approx INSPIRATION / \propto WORK).$$

DEAR HANS ULRICH —
HERE IS THE EQUATION.
IT WORKS!

YRS IN ART,
JOHN

J. G. Ballard

Sex x technology = the future

[signature]

Cecil Balmond

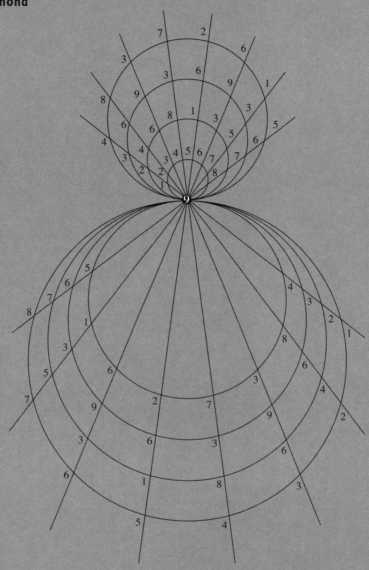

Multiplication Table reduced
to single digits — strange Mandala

Matthew Barney Preliminary Libretto for 'Ancient Evenings'

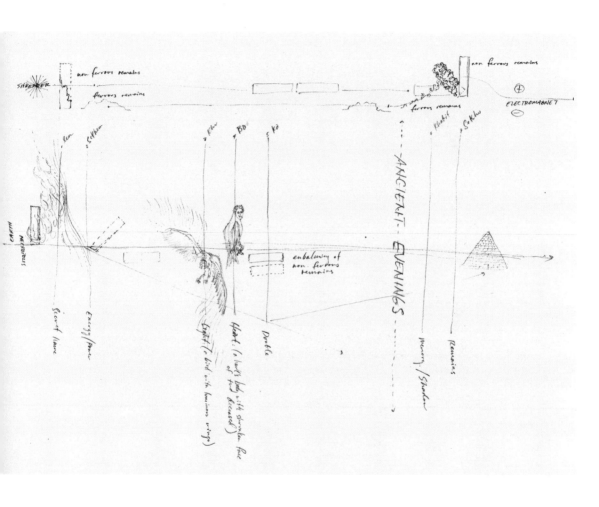

Simon Baron-Cohen

SEXING THE HUMAN BRAIN

Female-typical brain : $E > S$

Male-typical brain : $S > E$

Autism-typical brain : $S >> E$

Where E = Empathy

S = Systemizing

$>$ denotes sig. discrepancy

$>>$ denotes extreme discrepancy

Simon Baron Cohen

Dara Birnbaum

FORMULA ONE / F1

For·mul·a or For·mu·la - a category of racing car according to technical specifications such as engine capacity, size, and weight, used as a basis for professional competition.
-Encarta® World English Dictionary © 1999 Microsoft

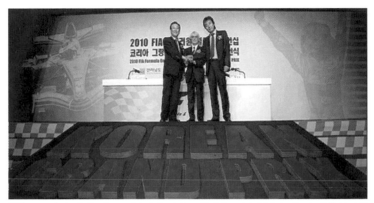

Within one week of each other, two events took place in Korea: North Korea tested its first nuclear bomb (October 9th) and "Korea" proudly announced that it will host its own *FORMULA ONE GRAND PRIX.*

FORMULA ONE /FI is considered the highest class of single-seat open-wheel formula auto racing. The *F1* world championship season consists of a series of races, know as *GRAND PRIX*, which are usually held on purpose-built circuits and in a few cases on closed city streets. The results of each race are combined to determine two annual World Championships: one for drivers and one for the actual constructions/contractors. As the most expensive sport in the world, its annual teams' budgets average in the hundreds of milllions of U.S. dollars. Thus, its economic effect is significant and its financial and political battles are easily observed worldwide. Its high profile and popularity also makes *FORMULA ONE* an obvioius merchandising enviroment.

SPEED AND VIEWERSHIP: As a massive television event, *FORMULA ONE*'s audience easily consists of millions of viewers watching races in more than 200 countries. The cars race at speeds of up to 350 km/h (about 220 mph). *THE FORMULA* introduces a number of restrictions and specifications, which cars must meet. These are designed, amongst other things, to keep the ever-increasing cornering speeds in safe ranges. The performance of the cars is highly dependent on electronics, aerodynamics, suspension and tires. *THE FORMULA* has seen many evolutions and changes through the history of the sport. For example, there have been many different types of engines: normally aspirated, supercharged, and turbocharged - ranging from straight-4 to H16, with displacements from 1.5 litres to 4.5 litres.

THE FUTURE OF THE FORMULA: There is always uncertainty about the future of the sport. *FORMULA ONE* went through a tough time in the early 2000s, when viewing figures dropped and many fans simply switched off. The massive commercial interests of car companies and team sponsors also are at odds with the demand for an exciting spectator sport, as the drivers are encouraged to reduce risk to satisfy the funders. Other factors include the use of driver aids (such as steroids, party ice and caffeine), supposedly taking the skill away from the driver and putting it into the hands of the mechanics. For this reason, many rule changes have been proposed for the future of *FORMULA ONE.*

ADDENDUM: The first world championship race, *FORMULA ONE*, came into being the same year that I was born: 1946, just after World War II ended (Hebrew calendar: 5706-5707).

- DARA BIRNBAUM, NEW YORK CITY, 2007

J — Modell

$$E_j = \sum_{i=1}^{m} X_i \cdot Y_i + A_e + A_v \qquad \begin{array}{l} i = 1 \cdots m \\ j = 1, \cdots w \end{array}$$

E_j = Kunstbewertung bestimmt durch wahrgenommene verstandesmäßig begriffliche und ästhetisch emotionale Merkmale i und durch die ästhetisch emotionale und verstandesmäßig begriffliche Aura

$E_j^* > E_j$ ⟹ Kunstbewertung durch alle Merkmale ist höher als die Kunstbewertung durch die wahrgenommenen Merkmale

• Je größer die 4 Komponenten werden, desto stärker ist die Annäherung von E_j nach E_j^*

E_j E_j^*

MDS

→ stellt die Ähnlichkeiten zwischen den Kunstwerken dar
→ keine Begründung der Ähnlichkeiten über die Merkmale
→ geometrische Position zweir K.werke
 ↳ identische K.werke → gleiche Position
 ↳ ähnliche K.werke → nahe beieinander
 ↳ unähnl. K.werke → weit voneinander liegend

Modell mit Ideal Kunstwerk

K wert → hoch, je näher das Kunstwerk
am Ideal Kunstwerk heranreicht.

Die Eigenschaften können gewichtet (W_K) werden
→ wichtigere Eigenschaft → hoher W_K-Wert
→ $W_K \uparrow \Rightarrow KW_j \uparrow$

$$KW_j = \sqrt{\sum_{K=1}^{m} W_K \left(B_{jK} - 3_K \right)^2}$$

B_{jK} = wahrgenommene intensitätsmäßige
Ausprägung der Eigenschaft K bei
dem Kunstwerk j (kognitive Komp.)

3_K = Ideal empfundene intensitätsmäßige
Ausprägung der Eigenschaft K
(affektive Komponente)

W_K = Bedeutungsgewicht der Eigenschaft K

KW_j = Kunstwert des K. werkes j

Louise Bourgeois

A LOVES B
AND B LOVES C.

THIS IS A STRANGE STATE OF BEING.

NOTHING CAN BE DONE.

THERE IS NO LOGIC.

IT IS AN UNRESOLVED MYSTERY.

Stewart Brand

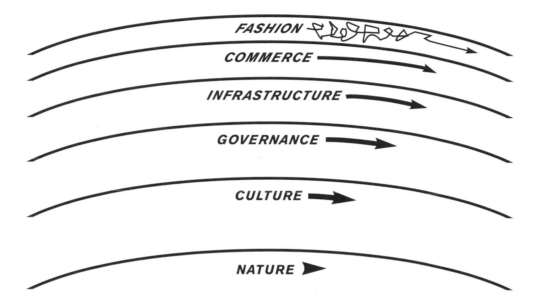

This is a cross-section of the pace layering of a healthy civilization.

The fast parts, like fashion and commerce, propose ideas and absorb shocks.

The slow parts, like governance and culture, set the rules, maintain continuity, and integrate lessons.

The fast parts get all the attention.

The slow parts have all the power.

Monday, February 22, 2007. I am in Victoria, British Columbia, Canada, staying at the Laurel Point Inn, designed by Arthur Erickson, overlooking Victoria's outer harbour. I am here for my mother's funeral, which is today.

My mother was born in 1912, and brought up in Shepherd's Bush, in London, before marrying a Frenchman, Marcel, who came from a family of French chefs, and opening her own business, a hair salon with a decidedly intellectual clientele, on King's Road, just before World's End. It was called Madame Marcel. I believe the shop is still there today.

Her husband flew with the Free French Air Force in World War II (which meant that he flew with whoever would have him, in this case, the Royal Canadian Air Force), and was shot down over Cologne. His co-pilot and best friend, my father, was sick that day. Perhaps out of guilt, but also out of love for both his friend and my mother, my father married my mother in a civil ceremony an unseemly six weeks later.

My mother came to Canada in the last months of the war in a boat full of war brides, accompanied by the fear of and the sound of German submarines. She traveled overland from Halifax to Vancouver, some 5,000 miles, and was struck by some of the local customs, such as eating corn-on-the-cob. She brought with her a bulging suitcase full of her most precious belongings: old silver given her by her wealthy auntie (we have it still); clothes designed by her best friend, a young couturier; and precious pieces of porcelain.

My mother found herself in an environment she had not fully apprehended: transported from the center of trendy London to my grandfather's chicken farm in Abbotsford, outside of Vancouver. Once my father returned, and I was born, we began a life of postings from one air-force base to another, from Fort Nelson on the Alaska Highway to St Jean d'Iberville, at the time a desolate little town south of Montreal.

What has all this to do with a formula, you may well ask, and I am asking that myself.

In 1965, when I began studying at the Architecture School of the University of Manitoba, Winnipeg, the one computer on campus occupied an entire floor of the engineering building. As someone with an interest in mathematics, and in computers, and particularly in geometry, I was invited to participate in a special project when the Engineering Department

acquired their first plotter. In my previous year I had built a model of an equation, using the armature of an old lamp shade (two concentric circles separated vertically in space), and joining a point at every 32nd of the diameter of the smaller circle to a point at every 64th of the diameter of the larger circle … or perhaps it was a point at every 64th of the smaller circle to a point at every 128th of the larger circle. Either way, the three-dimensional shape that evolves is the same. My project for the computer project was to translate this form into algebraic terms, create the stack of punched cards that wrote the program, and instruct the computer to draw a two-dimensional view of this curve from a point directly above.

This I did. My instructor, who was, by the way, one of the messiest men I ever encountered, and brilliant, was dubious at first, but curious. He took my stack of cards one evening and returned the next morning in great excitement: the plotter was slowly and laboriously drawing my curve.

The plotter took a full 24 hours to draw the curve, thus effectively closing down the university computer for a night and a day.

It was during this period that I was visited, one evening, by Jerry Rubin, later to become a founder of the Yippies, who was on his way from Vancouver to Toronto, and then south to New York, bearing with him a text he had rubbed from a grave: Desiderata. My mother was visiting at the time and the three of us sat up late into the night, while he expounded on the fascism of the nuclear family, and other wisdoms designed to offend my mother. To her credit, she was perfectly charming through the entire episode, although somewhat upset and offended the next day.

For the last two months **I have been trying my best to re-create the algebraic formula that lies at the center of this time: it marks my emerging life as a hippy, a founder of a commune, an underground paper and a free school, from which experience General Idea was improbably born; and my life as a mathematician,** my mind an endless plotting of three-dimensional curves, probabilities and possibilities, budgets and potentials. I realize that in the passing of the years my abilities have become sadly depleted: I am no longer capable of re-creating this project, which seemed so simple at the time, and which marked out, by a complex of overlapping, three-dimensional curves, the life that was to be mine.

Maurizio Cattelan

```
---------------
(it s more)
(about possibilities)
(not solutions)
---------------------------------
      0
     0
    o  ^_-^
      (oo)\-----------
      (--)\         )\^
       | |------w |
       | |       | |
```

Gregory Chaitin

The Halting Probability Ω: Concentrated Creativity

The number Ω is the probability that a self-contained computer program chosen at random, a program whose bits are picked one by one by tossing a coin, will eventually stop, rather than continue calculating for ever:

$$\Omega \;=\; \sum_{p \text{ halts}} 2^{-|p|}$$

Surprisingly enough, the precise numerical value of Ω is uncomputable, in fact irreducibly complex.

Ω can be interpreted pessimistically, as indicating that there are limits to human knowledge. The optimistic interpretation, which I prefer, is that Ω shows that one cannot do mathematics mechanically and that intuition and creativity are essential. Indeed, in a sense, Ω is the crystallized, concentrated essence of mathematical creativity.

Paul Chan

PROGRESS = REGRESSION

PROGRESS = REGRESSION

ADORNO AS
READ BY PAUL CHAN

$$A = B$$

$$A = B$$

$$B = B \qquad B = B$$

FRANZ ROSENZWEIG

AS READ BY PAUL CHAN

Richard Dawkins

$$\text{POWER OF A THEORY} \quad = \quad \frac{\text{NUMBER OF THINGS IT EXPLAINS}}{\text{NUMBER OF THINGS IT NEEDS TO ASSUME}}$$

BY THIS MEASURE, DARWIN DISCOVERED WHAT MAY BE THE
MOST POWERFUL THEORY IN ALL OF SCIENCE:

$$\text{POWER OF DARWIN'S THEORY} \quad = \quad \frac{\text{A BILLION WELL-ADAPTED SPECIES}}{\text{GENES EXIST}}$$

... for mutation, competition, selection and evolution follow
inevitably from the existence of high-fidelity replicators

Tacita Dean

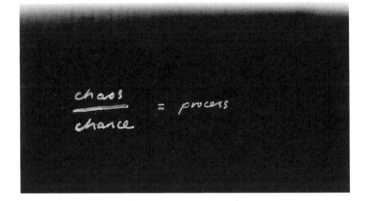

Jamel Debbouze

Y a plus de Sentiments,
Y a que des Centimetres...

Y a plus de Voyous
Y a que des Voyelles.
noi Je suis une Consonnes...

Jamel Debbouze !

Thomas Demand

$2 \times h + b = 62$ to 64 cm

The slope of a staircase
is expressed
as the relationship between
the tread width (b)
and the rise (h) of the steps.

A good slope ratio,
around 17/29 cm,
gives an inside-leg measuremen
between 62 and 64 cm,
as expressed in the above formula,
e.g. 2×17 cm $+ 29$ cm $=$
63 cm.

David Deutsch

$$\mathrm{Tr}_2\left[U\left(\hat{\rho}_{in} \otimes \hat{\rho}_{loop}\right)U^{\dagger}\right] = \hat{\rho}_{loop}$$

This is an equation from my paper 'Quantum Mechanics near Closed Time-like Lines', which appeared in *Physical Review* D44, 3197–3217 (1991). It is the equation for the state of a quantum computer that is, by whatever means, provided with a method of sending its output ρ_{loop} back in time to interact with its input ρ_{in}. The universality of quantum computation ensures that the results also apply to any time-travelling physical system, not just a computer. The self-consistency of this equation proves the self-consistency of time travel in quantum physics. Analysis of the equation shows that if we had a time machine and tried to use it to enact 'paradoxes' (like going back in time to prevent our building the time machine), we would simply go back to a universe in which those events really happened. U and U^{\dagger} represent the motion – any motion we like – that we would initiate when we emerge from the time machine. 'Tr$_2$' represents the operation of selecting which part of the computer's state it will send through the time machine. And \otimes represents the combining of the input information with that which has travelled back in time.

避孕药的模式

Gu Dexin

丘脑下部

FSH LH

垂体前叶

避孕药 ⊣ ⊢ 避孕药

FSH LH

卵巢

HO— 雌酮

HO— H 雄酮

OH
H
O— 睾酮

CH_3
$C=O$
O— 黄体酮

 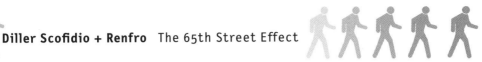

$$65^{\text{th st}} \text{effect} = \frac{\underset{\text{sp}}{\LARGE\text{walker}}}{\text{di}\left\{ {}^{=}_{=}\text{A}_1^{=}\right\}} \text{ x } \underset{\text{as}}{\text{brain}} \quad \boxed{\text{i}_\text{u} \propto \text{i}_\text{d}}$$

The formula was devised as a way for the Lincoln Center clients to understand the criteria for information design along 65th Street, a 700-foot-long street.

The translation:

The 65th Street Effect is the product of the average walking speed divided by the distance between attractors, multiplied by the attention span of a cyclical rotation of information meant to be utilitarian in direct proportion to information meant to produce delight.

Cory Doctorow

P=NP?

LIMITS OF COMPUTATION

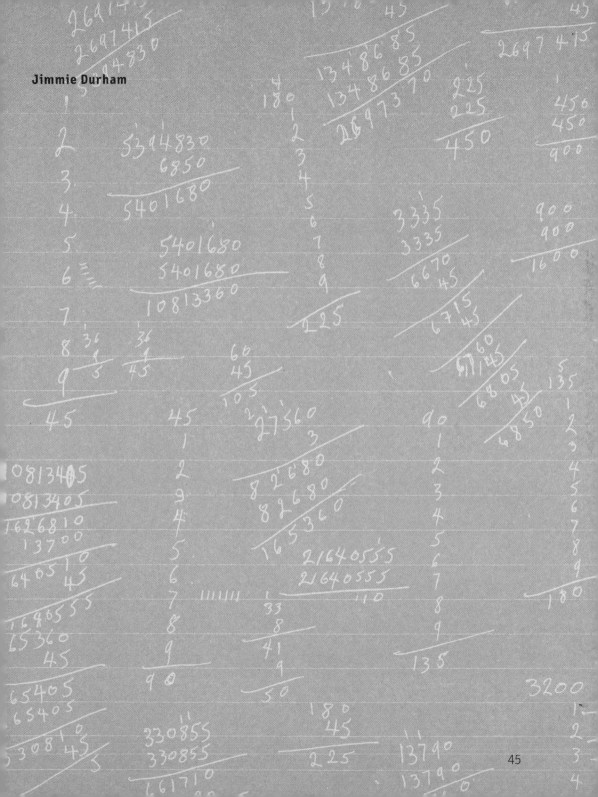

Jimmie Durham

Freeman Dyson

$$\sum_{n=1}^{\infty} \tau(n)x^n = \eta^{24}(x) = x \prod_{m=1}^{\infty} (1-x^m)^{24} \quad ,$$

$$\tau(n) = \sum \frac{(a-b)(a-c)(a-d)(a-e)(b-c)(b-d)(b-e)(c-d)(c-e)(d-e)}{1!\ 2!\ 3!\ 4!} \quad ,$$

summed over all sets of integers a, b, c, d, e, with

$$a, b, c, d, e \equiv 1, 2, 3, 4, 5 \ (\text{mod } 5) \quad ,$$

$$a + b + c + d + e = 0 \quad ,$$

$$a^2 + b^2 + c^2 + d^2 + e^2 = 10 \ n \quad .$$

The first is Ramanujan's definition of his tau-function.

The second is a formula for the tau-function which I discovered about forty years ago.

It is not important, but it is the most beautiful thing that I ever discovered, with an unexpected five-fold symmetry.

It turned out to be a special case of a more general set of identities discovered by the mathematician Ian MacDonald.

EXPECTATION FORMULA/2006

YOU

Thought

SENSE

REAL

UNCERTAIN

CERTAIN

THE LOOPING RINGTIME
(REAL) oy/sl.

Paul Elliman Writing the Voice

Brad, thinking about your work on speech and voice simulation I have a couple of questions regarding my own interests in the voice. First, though, can you briefly summarize the practical context of your work on voice equations? Is it a way of understanding aspects of how a voice is produced? Is it working towards some kind of technical production of voice?

Paul, you ask a very good question there. The research that I do with regard to speech simulation is primarily for the purpose of helping us understand how humans produce speech. If one builds a mathematical model that accounts for much of the physical and physiological processes of our speech-producing mechanism (respiratory, laryngeal, articulatory, aerodynamic, biomechanical, and acoustic), then tests and experiments can be performed with the model to uncover how all of the various systems are coordinated and coupled to generate intelligible speech. Also, it can help us understand how speech may become disordered. One of the difficulties of studying speech is the relative inaccessibility of the parts of the system for making measurements. In contrast, a model (assuming that it is validated as a reasonable representation of speech) allows for complete accessibility to all parts. As with any type of physical modelling, speech simulation must be carried in concert with as much experimental work as possible.

As an analogy, simulating speech production or some aspect of it is a lot like simulating the airflow across the wing of an airplane or the vibratory characteristics of an engine block in an automobile. The difference is that both of the latter would be performed in order to guide the design of a human-made structure, whereas speech production is simulated in order to understand the function of a naturally occurring structure. There is a caveat, however: some work is being done to create computational models that may predict surgical outcome before the surgery is performed. This may allow for a revision of the surgical procedure if the simulation predicted an undesirable outcome.

These are the primary reasons for simulating speech. A simulator does, however, potentially have the ability to speak words and sentences. This is difficult at present, largely because of our lack of knowledge about how the movements of all the subsystems are coordinated.

Other forms of speech synthesis contrast with speech simulation in that they are designed to accurately produce the acoustic output of speech without regard to the physics and physiology used by humans to produce that signal. These types of systems are more computationally efficient and "to the point" if your only goal is the production of the speech sound.

In your work there is both the sense that everything (even a voice) can be "described" by equations, or sequences and chains of equations, but also that complex forms or actions (such as a voice) ultimately elude ever being fully represented by an equation or formula.

It is conceivable that the biomechanical, aerodynamic, and acoustic detail of a human speech production system could be represented by many, many equations that would form a complete mathematical model. On the other hand, the complexity of such a model would be overwhelming – and, in many ways, would become less useful than a simpler model because it would approach the same level of complexity as the human itself – not to mention the computational power needed to perform simulation. But even if such a model existed it still doesn't describe perhaps the most important aspect of speech production: the orchestrated contraction of some fifty or more muscles that move structures to create air pressures and airflows at precisely the correct points in time for intelligible speech to result. Also the model doesn't end with a mathematical description of the physics – ultimately we must keep working toward the brain to figure out how it all works.

I keep replaying TheFreeDictionary's audio file for the word "equation" (http://www.thefreedictionary.com/equation). This is an example of what you refer to as computationally efficient speech synthesis, but in no way approaches anything close to an actual vocal simulation. You're saying that no single equation could describe the pronunciation of even so much as this word …

That's right. The pronunciation of "equation" or any word or phrase can't be represented by a single equation. The number of equations, and the physical quantities they would represent, depends on the level of complexity desired.

To describe a word like "equation" in terms of a simulation of speech would require that a mathematical model that captures the biomechanics of the respiratory, laryngeal, and articulatory system exists. Additionally, the model would need to be augmented with additional mathematical models of the aerodynamics of the airway system as well as the sound-wave propagation through the airways. A word would then be simulated by supplying input signals to appropriately activate (move) each of the biomechanical systems with precise coordination – this is essentially a

simulation of human speech production – and would result in air pressures, airflows, and sound waves being generated. The final product would be the sound emitted at the lips. I recently coauthored an article concerning a very simple model of the vocal folds. There are 60+ equations in this article and the results could not be replicated without making use of the equations of the original model on which this one is based. Further, successful implementation of this model would only produce the sound at the vocal folds – not speech; that would include a great deal of additional modelling.

If the interest was only in a mathematical description of the sound wave (of TheFreeDictionary's "equation" for example), the complexity is perhaps somewhat reduced. But even so, a word could not be expressed as a single equation, rather it would be many equations describing the acoustic characteristics of the sound wave.

Can you render an example of even the smallest part in the form of an equation?

Okay, since you ask for it, the following equation would produce an approximate waveform corresponding to a vowel sound. This is a simple, "brute-force" representation of a complex waveform – it contains no information about how a speaker may have produced the sound. The \sum symbol represents the summation of the elements within it, t is the independent variable of time; other variables are defined below.

$$S(t) = (1 - \cos(2\pi t/T)) \left(\sum_{i=1}^{N} a_i \sin(2\pi f_i t) \right)$$

When the equation is used with the following input data, it would produce an approximation of the the first vowel in the word "equation" ("ih") spoken by me. These data would be different for a different person or for a different point in time within the word.

$$t = [0 \ldots 7] \text{ and } T = 0.1 \text{ seconds for this particular case}$$

$$f_i = 108i \qquad i = [1 \ldots N] \text{ and } N = 37 \text{ for this case}$$
$$\begin{aligned} a_i = [&2.21, 2.65, 1.40, 5.21, 0.70, 0.42, 0.21, 0.08, \\ &0.08, 0.06, 0.08, 0.11, 0.08, 0.11, 0.11, 0.24, \\ &0.39, 0.83, 0.99, 0.57, 0.32, 0.42, 0.5, 0, \\ &0.55, 0.26, 0.21, 0.16, 0.19, 0.16, 0.16, 0.24, \\ &0.29, 0.32, 0.37, 0.29, 0.19, 0.19] \end{aligned}$$

The a_i and f_i can be plotted against each other to graphically show the **amplitude spectrum** of the "ih" vowel. The frequencies and amplitudes in the spectrum change continuously as we speak – hence there would need to be new data fed into the equation at small increments of time to reproduce a word.

Phew! Many thanks for showing me this equation. Brute-force or not it seems like an incredible idea. And thanks for the discussion. I wanted to get a sense of the role of equations in your work, versus the massive level of complexity that is being touched on by these kinds of attempts at "describing" what is actually happening in order for the voice to do what it does. Good luck with everything; long live the voice and its equations!

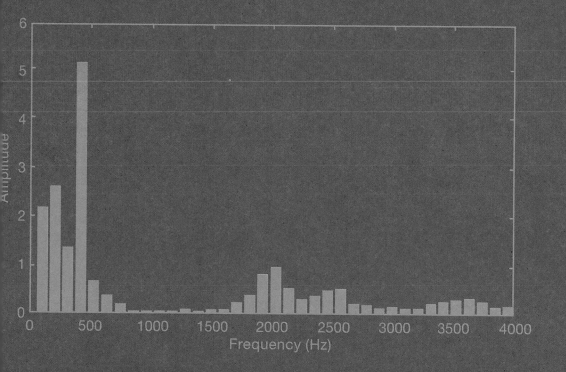

Thanks to Brad Story, Ph.D.
Associate Professor,
Department of Speech and Hearing Sciences
University of Arizona

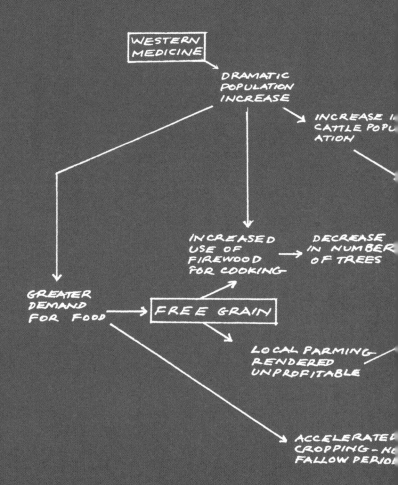

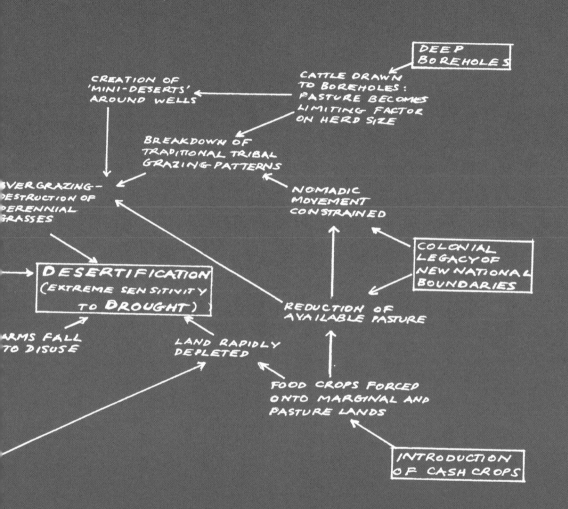

HOW THE SAHEL WAS TURNED INTO A DESERT BY GOOD INTENTIONS: WESTERN MEDICAL AID, THE INTRODUCTION OF CASH CROPS, THE DRILLING OF DEEP BOREHOLES AND TONS OF FREE GRAIN WERE ALL SUPPLIED TO AVERT DISASTERS, ONLY TO BECOME THE ENGINES OF GREATER DISASTERS.

ADAPTED FROM 'ETHICAL IMPLICATIONS OF CARRYING CAPACITY' BY GARRETT HARDIN

1985

Tim Etchells

two people

+

talking

+

occasional silence

x

time spent walking together

=

solutions/
problems/

Cao Fei Pleasing Formula

250 g geschälte Mandeln

250 g Puderzucker

5 Eßlöffel Rosenwasser

3 Tropfen Bittermandelöl

Fig. 13

Simone Forti The four floats

This drawing first appeared on the cover of my book *Handbook in Motion*. It was inspired by hearing of a tool used in ancient Egypt to measure something about the Nile. The text is new. While looking for how to place the elements together I finally just dropped the text onto the drawing. Then I thought of Marcel Duchamp's *Three Standard Stoppages*.

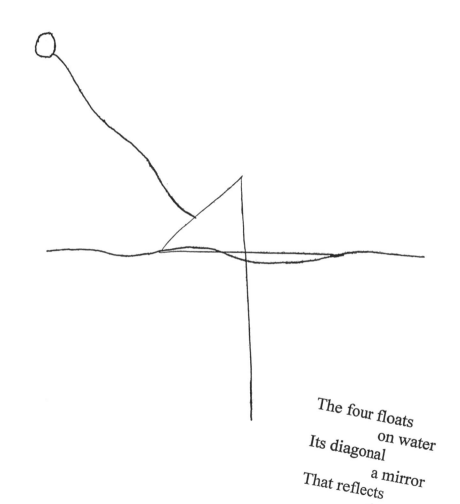

The four floats
 on water
Its diagonal
 a mirror
That reflects
 the sun's rays
This way

 that way

Jacque Fresco

EVENTUALLY ALL RE
MUST BE SHARED BY
COMMON HERITAGE O

IF THE HUMAN RACE IS TO SURVIVE, WE
MUST EVENTUALLY DECLARE ALL EARTH'S
RESOURCES AS THE COMMON HERITAGE OF
ALL THE WORLDS PEOPLE.

Jacque Fresco

Yona Friedman

2+2, or 3+1, or 1+3
or 5-1
are not the same
process

addition can not
lead to infinite :
there is no process
reaching infinity

a process can be
described
as a chronologic
sequence

"Complicated order"
can be read
as a linear
sequence

reading is linear
(topologically)

a DVD contains
the linear descript'n
of a complex
universe:
both space and time

THIS DRAWING VISUALISES THE CHARACTER OF COMPLICATED LINEAR ORDER: IT HAS TO BE READ THE WAY IT IS NOT REALLY DIFFICULT HOW OF THE

2

a dog sees
a blurred
holistic image
of the world

TREE

MOUNTAIN

TREE

TREE

HOUSE
FAR AWAY

FIELD

humans see
the world
analytically:

an accumulation
of distinct things

I invent
names

a penny
an onion
a dog
a woman
an elephant
an antelope
a well
an idiot
a minute
a splash
a whistle

distinct things
have "names":
they can be additioned
but they don't imply
an underlying order

3

D BOND STREET

ON W1S 4QB ENGLA

409-2790

ENT NAME:

DRES

Proposal for a necklace, the equation '∃!:=:⇔' engraved on a Tiffany's sterling silver coin edged tag pendant on a 20" chain. The equation exploits the language of pure mathematics to loosely assemble the sentence 'There exists only one definition for everything, everywhere at any one time.'

TCODE:

TIFFANY & CO.

OLD BOND STREET
25 OLD BOND STREET
LONDON W1S 4QB ENGLAND
020-7409-2790

TDA..........1/1..........

CLIENT NAME: ▓▓▓▓▓▓▓▓▓

BSN COD: 1136GAN

ADDRESS: ▓▓▓▓▓▓▓▓▓▓▓

COMPANY: Studio Grandi

POSTCODE: ▓▓▓▓▓▓

QUANTITY: 11 (Eleven)

PHONE / FAX: ▓▓▓▓▓▓▓▓▓

DST CATALOGUE NO.:

Tand Co. CEDPSS 16"
2000 1122

ARTWORK:

PRODUCT:

Didacteas

There exists only one
definition for everything
everywhere at any
one time.

DELIVERY: SD (ED)

STANDARD DELIVERY OR EXPRESS. FOR
STANDARD DELIVERY TO ADDRESSES WITHIN
THE UK, PLEASE ALLOW 7 WORKING DAYS.
CHARGE IS £5 PER ADDRESS. FOR EXPRESS
DELIVERY TO ADDRESSES WITHIN THE UK,
PLEASE ALLOW 2-3 WORKING DAYS. THE CHARGE
IS £15 PER ADDRESS. ON ORDERS OVER £75,
THERE IS COMPLEMENTARY EXPRESS DELIVERY.
FOR DETAILS ON OTHER DESTINATIONS OR SERVICES,
PLEASE CALL CUSTOMER SERVICE AT 00 800 2000 1122.

Centred

PSDA: Centred
A/W F/M: 5
TTT: 165328TTT

NOTES: Coin Edge tag
Pendant, Sterling silver
20" chain €125.00 ea

A/W F/M: 5
TTT: 165328TTT
PROD CODE:

A/W F/M2: 5
TTR: N/A
CIST:

REG:

REG 777:

Gilbert + George

AN
GION

Gilbert and George
2007

Simryn Gill

- Encyclopaedia of Modern Architecture.
 Thames + Hudson 1963
- National Geographic. Vol 160. no 5. 1971
- The Collected Works of Mahatma Gandhi.
 Vol. XXXIII, Ministry of Information + Broadcasting
 Govt. of India, 1969.
- A J Henderson, The Junior Geography
 The Clarendon Press, London, 1921
- John le Carré, Our Game, Hodder, London, 1995
- Marion Wood, Addiction to Perfection,
 Inner City Books, Toronto, p. 82

Simryn Gill · May 2007

Russell's Paradox: The assumption that sets can be
freely defined by any criteria is contradicted
by a set containing exactly the sets that are not
members of themselves.

Liam Gillick

Seven tons of industrial production divided by eight weeks of management stasis multiplied by two days of complete stagnation added to twelve months of reduced demand

Douglas Gordon

one step at
a time.

Dan Graham

COMMON DRUG \ SIDE EFFECT	Anoxemia (Appetite loss)	Blood clot	Blurring of vision	Constipation	Convulsion	Decreased libido	Dermatosis	Depression, torpor	Headache	Hepatic disfunction	Hypertension	Insomnia	Nasal congestion	Nausea, vomiting	Pallor
STIMULANT also **APPETITE DEPRESSANT**															
Dextroamphetamine (Dexedrine)	●			●	●				●			●	●	●	
Methamphetamine chloride (Desoxyn)	●			●	●				●			●	●	●	
ANTI-DEPRESSANT															
Iproniazid				●					●	●	●				
Trofanil			●				●		●		●				
TRANQUILIZER															
Chlorpromazine				●		●	●	●	●						●
Hydroxyzine				●			●	●	●					●	●
Meprobamate					●			●			●				
Promazine			●				●	●	●						
Resperpine	●				●	●	●	●				●	●		
Thiopropazate			●	●	●		●	●	●	●		●		●	
SEDATIVE															
Barbitol			●					●						●	
Phenobarbitol			●					●						●	
ANTI-MOTION SICKNESS															
Dimenhydrinate (Dramamine)							●	●						●	
Marezine							●	●							
Meclizine							●	●						●	
CONTRACEPTIVE															
Norethynodrel (Enovid)		●	●						●	●				●	●

Loris Gréaud Formula for a Silent Firework

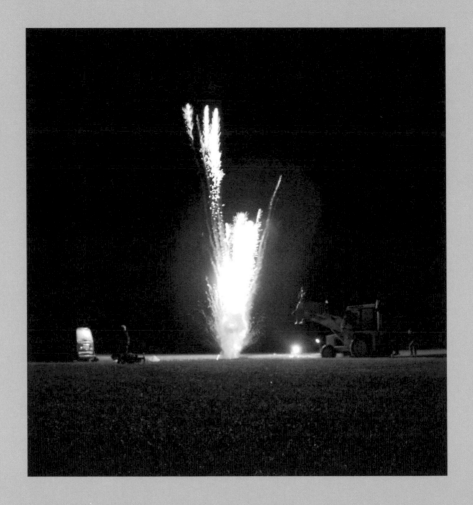

– **KNO3** (Potassium nitrate) 75% + **Na** (Sodium) 5%

– **S** (Sulphur) 10 to 15% + **Sr** (Strontium) 8%

– Charcoal 10 to 15% + **Ba** (Barium) 5%

 + **Cu** (Copper) 10%

Joseph Grigely $W \longrightarrow T_1, T_2, T_3, \dots T_N$

The dilemma is illustrated by the rhetorical argument often posed by scholars in the fields of textual criticism and analytical bibliography: if *Mona Lisa* is in the Louvre, where is *Hamlet*?

The dilemma is important because the relationship between a work of art or literature, and its material manifestations in culture, is not always the same. A work can be said to have many material manifestations (or 'events'), some authorized by the author/creator, some not authorized: editors change texts, texts are republished in new contexts, works of art are reframed, relabeled, reinstitutionalized, a process of repetition (of the abstract 'work') and variation (of its material and institutional frames) resulting in multiple manifestations. If our reading of the work results in perpetually deferred or unstable signifieds, it is partly because the signifiers themselves are unstable to begin with.

Neither Benjamin (in "The Work of Art in the Age of Mechanical Reproduction") nor Barthes (in his essay "From Work to Text") addresses the ways a work of art or literature experiences change in the process of being disseminated in culture. Both assume that 'reproduction' is a stable process.

How then can we illustrate a theory of textual dynamics?

One way is to offer a clarification of the terms 'work' and 'text', as I previously outlined in *Textualterity: Art, Theory, and Textual Criticism* (University of Michigan Press, 1995). This formulation inverts Barthes's terminology. Where a work is an expression of totality—*Mona Lisa* and *Hamlet* are 'works'—the totality is immaterial. The existence of works like these is that of Platonic form or idea. A text, in turns, is either an event or an outcome. The manifestation of the work is that of a polytext of seriated texts and versions. This formulation may be expressed by the equation

$$W \longrightarrow T_1, T_2, T_3, \dots T_N$$

where W = work and T = text. It is important to note that the work is not equivalent to the sum of its texts (which would create a monolithic hybridized text), but instead is an ongoing—and infinite—manifestation of textual events, whether those texts are authorized or not. This includes texts like censored and condensed versions of literary works, and recontextualized images of visual works of art that take into account their very recontextualization. While not 'authorized', such texts are disseminated in society and read by individuals, and therefore constitute culture itself.

The conflation of textual making and remaking guarantees that the proliferation of culture depends not so much on the author/artist's explicit intentions, but on the tension between those intentions and the subversion of them.

'Performance' (in music, theatre, speech) can also be included in this formulation. Where a series of performances is based on a specific text (what Nelson Goodman might call a 'score'), and given

$$W \longrightarrow T_1, T_2, T_3, \dots T_N$$

then we may say

$$T_x \longrightarrow P_1, P_2, P_3, \dots P_N$$

Richard Hamilton A cock and ball story/Ceteris paribus August 2006

A Wrangler[1] of Trinity Hall
had the most mathematical ball.
The square of its weight,
plus his prick minus eight,
equalled Pi times the cube of fuck all.

Given: $\begin{array}{l} \text{O} \\ \text{I} \end{array}$ The ball
 The prick $O^2 + I - 8 = \pi \times (\phi\alpha)^3$

Proof of this apparently simple assertion is difficult to achieve. Data are so meagre that the outcome must remain in the realm of philosophy. The identity of the wrangler is unknown. Getting hold of his singular ball is certainly optimistic[2].

Measuring the weight of 'I' would challenge the laboratory skills of a Robert Hooke because another imponderable is immediately exposed. Were the nub of 'I' to be attached to a spring balance by a piece of cotton thread[3] of a known weight (fig. 1) a measurement could be established. However, there is a distinct danger of the experiment triggering a change of density[4] and therefore an increase of weight. Engorgement of 'I' would have the effect of elevating the organ to an extent that 'I's weight could register zero, or indeed (minus the weight of thread) a negative value. Duchamp's algebraic comparison in his Green Box leads us into a similar aesthetic hiatus.

Algebraic comparison

$\dfrac{a}{b}$

a being the exposition

b " the possibilities

the ratio $\dfrac{a}{b}$ is in no way given by a number c

$\dfrac{a}{b}$ = c but by the sign which separates

a and b; as soon as a and b are "<u>known</u>" they become

new units and lose their numerical value (or in duration);

the sign of ratio – which separated them remains (<u>sign of the</u>

<u>accordance</u> or rather of . . . ? . . . look for it)

[1] At Cambridge University, England, the person placed first in the mathematics tripos was designated a senior wrangler. Other students who complete the tripos with first-class honours were nominated 'second wrangler', 'third wrangler' etc. according to their assessment.

[2] Max Planck's uncertainty principle.

[3] See Roger Penrose on string theory. *Roads to Reality: A complete guide to the laws of the universe*, (Jonathan Cape, 2004).

[4] See Marcel Duchamp's Green Box note headed 'Laws, principles, phenomena'. 'Phen. or principle of oscillating density, a property of the substance of brand bottles'. MD posits a bottle of Benedictine in his famous conjecture.

Marc Hauser

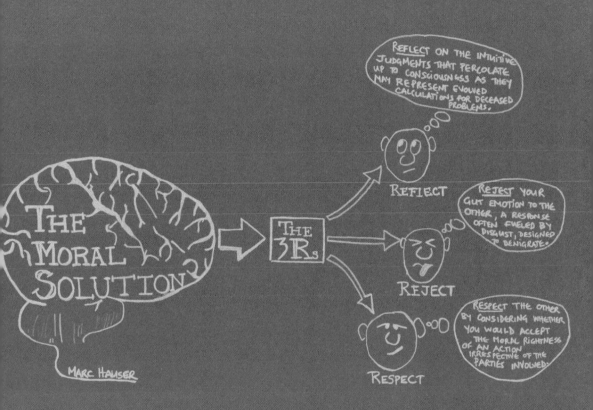

Carl Michael von Hausswolff

Ketamine (C₁₃H₁₆ClNO)ˣ

(Ketamine)
is used to indicate
a state of consciousness
alteration which in-
volves a large degree
of dissociation from
the body.
This drug was intro-
duced to me by:

(Eric Burdon)
in 1985.
Sharing a va-
cation in
Spain admiring
each others
hearing - and
leg-problems,
we' might even
have tried it.

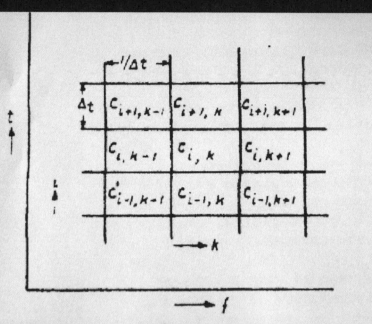

Fig. 3. MATRIX OF ELEMENTARY SIGNALS REPRESENTING AN ARBITRARY SIGNAL

Photograph of Dennis Gabor's 'Matrix of elementary signals representing an arbitrary signal', from Dennis Gabor, Acoustical Quanta and the Theory of Hearing', *Nature*, no. 4044, 3 May 1947

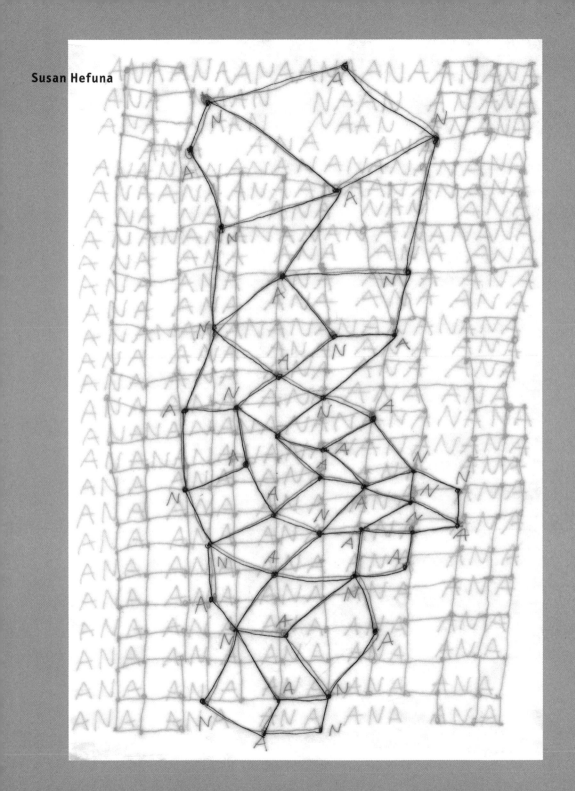

Susan Hefuna

Roger Hiorns

AN EARLY EQUATION FOR THE ABOLITION OF METAPHOR

$$\left(A = -M \right)$$

Nikolaus Hirsch

RH

relative humidity = $\dfrac{\text{absolute humidity}}{\text{saturation}} \times 100$

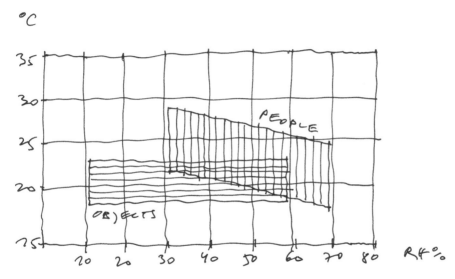

RH in the museum:

Objects vs People

People and objects respond to the same physical variables of environmental change. But there is a crucial difference: people are primarily temperature sensitive, whereas most museum objects are humidity sensitive. A 4% relative humidity (RH) change has the same effect on objects as a 10% change in temperature. The same change in RH has the same effect on people as a 0.1° change in temperature. This means that objects are a hundred times more sensitive to RH than people. Note: objects are generally less tolerant of environmental change than humans. There is no reliable relationship between human comfort and the suitable environment for an art work.

Damien Hirst Newton's Colour Wheel

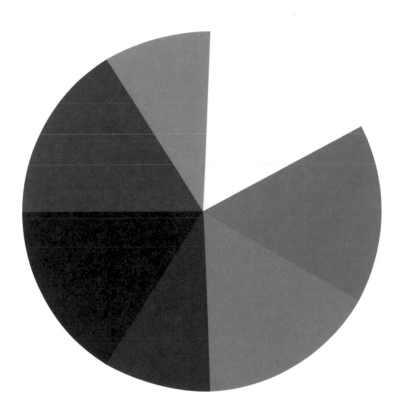

Albert Hofmann

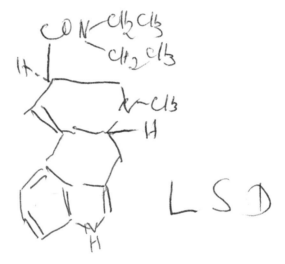

Carsten Höller

Dear Habil,

I don't think doubt has a formula.

Ever,

habil

Michel Houellebecq

$$\aleph_0 + 1 = \aleph_0$$

L'opération se réitère ; on peut ainsi ajouter (ou soustraire) des éléments en nombre infini à un ensemble sans modifier son cardinal.

Card N est noté \aleph_0.

Card R = 2^{\aleph_0}.

Le plus petit transfini supérieur à \aleph_0 et noté \aleph_1.

Cantor conjectura en 1878 que \aleph_1 = Card R ; Cohen montra en 1963 que la proposition était indécidable.

L'introduction des transfinis me paraît une des avancées les plus remarquables de l'esprit humain.

Michel Houellebecq.

Pierre Huyghe

EXHiBiTiON²

Ryoji Ikeda The Irreducible (reference: $V \neq L$)

The inequality proclaims that the set-theoretic
universe is richer than Goedel's L, which
consists of all sets obtained by transfinite
recursion of constructible set operations.
The inequality is known to be independent
from usual axioms of mathematics. Still it
holds in a very strong way – e.g., if there
are very large infinite cardinals (courtesy
of Sakaé Fuchino).

Charles Jencks

$$I + E = M$$

'Intelligence and Effort together make up Merit',
taken from Michael Young, *The Rise of Meritocracy*, 1958

Wang Jianwei Document

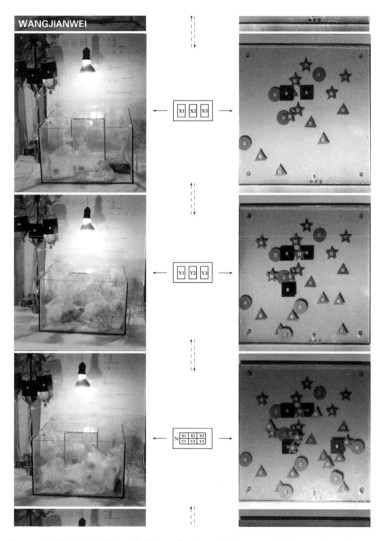

Document tries to adopt the methodology of systematic theory as artistic experimental method. At the same time, it is a model of 'control theory' and 'recognition of Art'.

1 Whether the experience of recognition of art can be connected completely, or some experience can exist and be across space at the same time.

2 The experiment enables material and goods to have openness and multiplicity, and exclude any kind of arranged domination.

3 The procedures are stopped and transferred by continuity; the outlook of material and vision methods must be produced within the relation of mutual reactions.

Michael Joo Distillation drawing 1

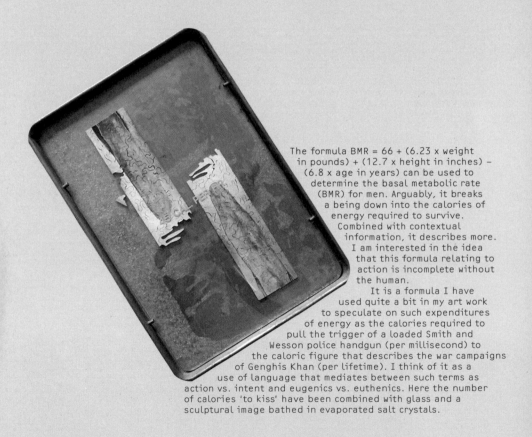

The formula BMR = 66 + (6.23 x weight
in pounds) + (12.7 x height in inches) –
(6.8 x age in years) can be used to
determine the basal metabolic rate
(BMR) for men. Arguably, it breaks
a being down into the calories of
energy required to survive.
Combined with contextual
information, it describes more.
I am interested in the idea
that this formula relating to
action is incomplete without
the human.
It is a formula I have
used quite a bit in my art work
to speculate on such expenditures
of energy as the calories required to
pull the trigger of a loaded Smith and
Wesson police handgun (per millisecond) to
the caloric figure that describes the war campaigns
of Genghis Khan (per lifetime). I think of it as a
use of language that mediates between such terms as
action vs. intent and eugenics vs. euthenics. Here the number
of calories 'to kiss' have been combined with glass and a
sculptural image bathed in evaporated salt crystals.

Július Koller

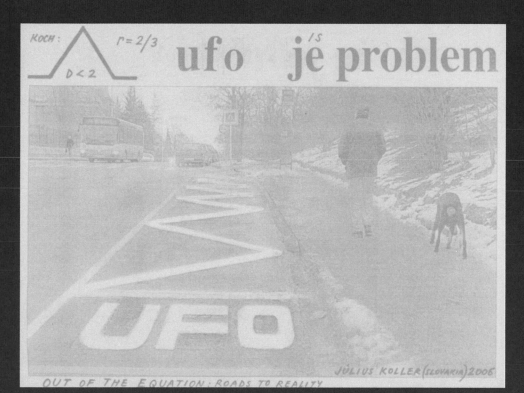

Koo Jeong-A

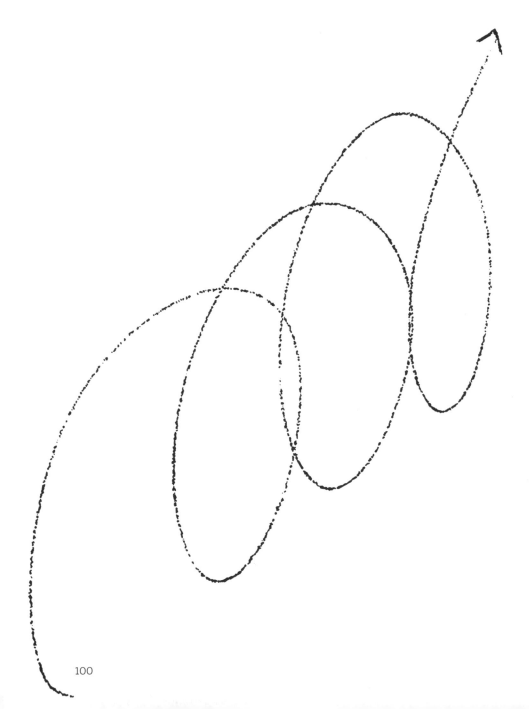

Rem Koolhaas euro formula

$$EU_d(\text{€}) = \lim_{15 \longrightarrow \infty} \int_{30°}^{75°} \frac{c(\text{€}) \, s(e + \text{€}) \, T°}{p(\text{€}) \, h(A + \text{€}) \, R}$$

T° = local temperature
p = population density
€ = local price level
A = alcohol consumption
h = historical values
c = local cuisine
s = social values (fashion, design, clubs, music)
e = economical infrastructure
R = amount of rain

An integral is a mathematical object which can be interpreted as an area or a generalization of area. Integrals, together with derivatives, are the fundamental objects of calculus. Other words for integral include antiderivative and primitive.

Jeff Koons

TRUST IN YOURSELF + FOLLOW YOUR INTERESTS + FOCUS

= OBJECTIVE REALITY

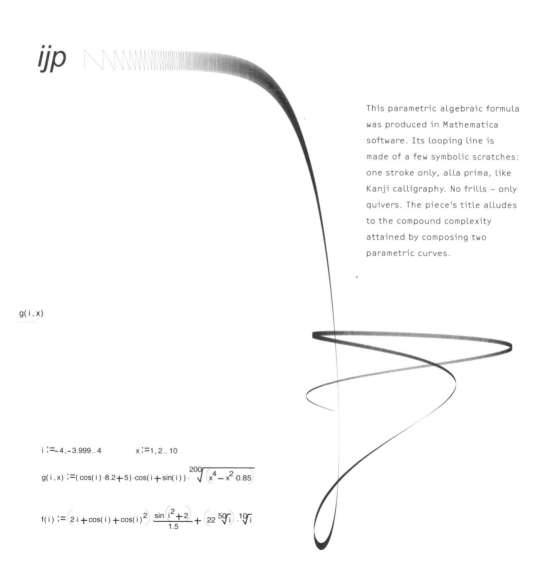

ijp

This parametric algebraic formula was produced in Mathematica software. Its looping line is made of a few symbolic scratches: one stroke only, alla prima, like Kanji calligraphy. No frills – only quivers. The piece's title alludes to the compound complexity attained by composing two parametric curves.

g(i , x)

$i := -4, -3.999 .. 4$ $x := 1, 2 .. 10$

$$g(i,x) := (\cos(i) \cdot 8.2 + 5) \cdot \cos(i + \sin(i)) \cdot \sqrt[200]{(x^4 - x^2 \cdot 0.85)}$$

$$f(i) := \left(2 \cdot i + \cos(i) + \cos(i)^2\right) \frac{\sin(i^2 + 2)}{1.5} + \left(22 \sqrt[50]{i}\right) \cdot \sqrt[10]{i}$$

f(i)

Benoit Mandelbrot

$$Z \longrightarrow Z^2 + C$$

B Mandelbrot

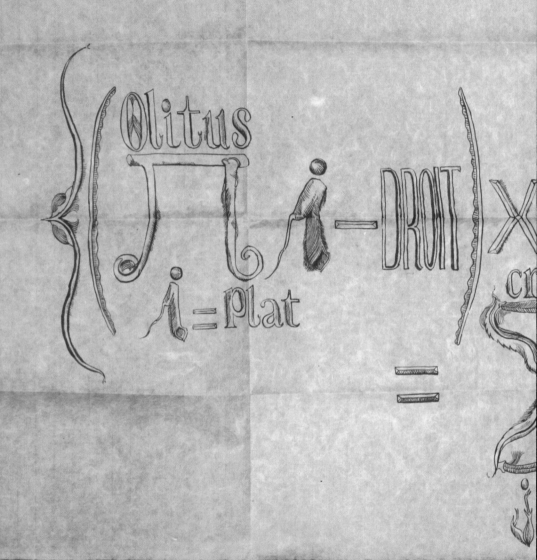

VAGUE \times cos π (BLANCHÂTRE)

$-$ (PARFOIS GRISÂTRE)

ORGANISE

ronçon

Enzo Mari Levels of Reality

All knowledge is based on lists of (apparently finite) assemblies of things, ideas, and interrelations. Curiosity and the tension towards the global inevitably hypothesize an all-inclusive whole. But this must inevitably be surpassed by a further whole of a superior level and so on ... indefinitely. It's comforting to know that this assertion, of intuitive nature, was proven through mathematical logic by Kurt Gödel.

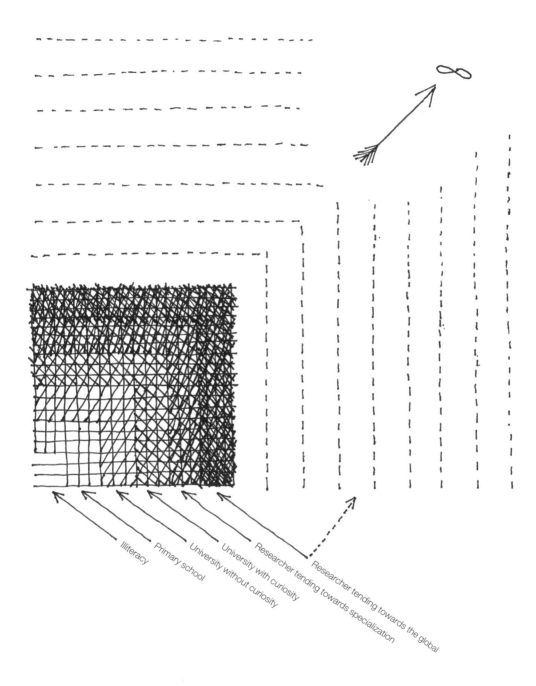

Illiteracy

Primary school

University without curiosity

University with curiosity

Researcher tending towards specialization

Researcher tending towards the global

Harry Mathews Mathews' Algorithm

I. *Materials*
Several – at least two – sets of heterogeneous sets are required.

II. *Arrangement*
All sets must contain the same number of elements.
2. Each element in a set must have a function equivalent to or consistent with the corresponding elements of the other sets. (If, for instance, the elements are words, the equivalence will be one of grammatical function.)
3. The sets are superimposed one above the other to form a table consisting of rows (the sets) and columns (the corresponding elements). Thus a table of 4 sets of 4 elements:

$$
\begin{array}{cl}
1 & a_1 \ b_1 \ c_1 \ d_1 \\
2 & a_2 \ b_2 \ c_2 \ d_2 \\
3 & a_3 \ b_3 \ c_3 \ d_3 \\
4 & a_4 \ b_4 \ c_4 \ d_4
\end{array}
$$

III. *Operation*
1. Shift each set $n-1$ places left. (In other words, shift the second set one place left, the third two places, etc.).

$$
\begin{array}{cl}
1 & a_1 \ b_1 \ c_1 \ d_1 \\
2 & b_2 \ c_2 \ d_2 \ a_2 \\
3 & c_3 \ d_3 \ a_3 \ b_3 \\
4 & d_4 \ a_4 \ b_4 \ c_4
\end{array}
$$

2. Read the columns downward starting with the initial elements of the sets (a). Four new sets result:

$$
\begin{array}{l}
a_1 \ b_2 \ c_3 \ d_4 \\
a_4 \ b_1 \ c_2 \ d_3 \\
a_3 \ b_4 \ c_1 \ d_2 \\
a_2 \ b_3 \ c_4 \ d_1
\end{array}
$$

A similar manipulation with a shift right will produce four other sets when the columns are read upward.

Example: Using letters as elements, the four words *tine, sale, male, vine* are transformed into *tale, vile, mine, sane* (shift left) and *tile, sine, mane, vale* (shift right). Words, phrases, sentences, paragraphs, and semantic material can be similarly recombined.

Meuser

In such a short time and in such a limited form, no explanation of the problem is possible. My basic idea is that I use the game to apply between 6 and 49 mathematical structures, and do not trust in hopeful assumptions or mystical delusions. I build up a grid that could be large or small, as long as it is regular. In practical, empirical tests, more patterns of probability always arise; exceptions are rare. Basic structures that are inaccurate or built on guesswork do not work so successfully. I allow a simple, definite, mathematical model to arise by chance. Chance decides the results. Within the everyday course of the game, an open process takes place; arbitrariness meets chance and only then becomes probability. My drawings are visually confused attempts to build up a workable grid.

Here is an example:

On the orange-coloured card, 56 x 7 figures from 1 to 49 are marked in vertical rows. Every figure matches up once with every other figure in the vertical rows, e.g. the figure 1 matches up with the figures 2, 3, 4 and so on up to 49. The underlying scheme is unrecognizable because the figures are arranged in ascending order; if you were to try and work it out without knowledge of the structure, you would go mad. The first square is decided on chance principles; it contains 49 figures. Two figures in row 49 gives 49 x 48 over 2 = 1176. Two figures in row 7 gives 7 x 6 over 2 = 21 x 56 = 1176. From this basic structure, larger structures can be derived.

A PAMPHLET AGAINST FORMULAS

The formula, already through its essentially modern concept, is outdated.
We believe that, in the future, there will be – and already there is – no more
grand account. When there is an inflation of formulas and possibilities, one
single formula can no longer work. The future *formula* will therefore consist of
a set of formulas ready to adapt. While half-life is shrinking, our daily lives reflect
the speed at which things date. Whether this is something we applaud or
dismiss no longer matters. Our daily routines have turned into virtual stock
markets: there are no more certainties, only fluctuating variables. While the
peaceful turns into the conflicting, water will be the new oil.

It seems that what we are in need of is a self-learning formula, an intelligence
that does not replicate or sustain denominators of formulaic consensus,
a recipe that no longer explicates that X = Y but that X becomes Y that
becomes A. It reminds us of Deleuze in 'Cinema 2' where he is talking
about Godard. He says that classical cinema was a cinema of 'OR':
this or that constantly being chosen (cinema's framing is a matter of
choosing what *not* to include in the shot, as much as what should be in shot);
instead, Deleuze says that Godard's cinema is one of 'AND': this AND that,
together; even if they contradict each other. Such a notion reminds us of
Fitzgerald's equation or formula that 'the sign of a first rate intelligence is one
that can hold two opposing ideas at the same time and still retain the function
of thought'. Formulas tend to rely on the '=' sign.

Rather than the X = Y, we propose the A – Z. *Relational decision-making, 24/7.*

October 2006

Michael Moorcock

A FORMULA FOR GIVING APPARENT RANDOMNESS A STRICT STRUCTURE (AN ANTIMODERN NOVEL, IF YOU LIKE)

Formula for "Mother London" — developed from earlier, more conventional, models

① The conventional structure for a modern novel (or novel sequence) such as my 'Colonel Pyat' sequence, where the structure of the individual novel reflects the structure of the whole sequence, can be shown as —

Introduction Development Resolution (and/or coda)
1 2 3 4

② The formula I used to give apparent randomness to my novel 'A Cure for Cancer' (also one of a sequence of four) was —

Development 1 Resolution Development
2 3 4
Introduction

Which was somewhat awkward —

③
— so for 'Mother London' I used a duodecimal system which gave me much greater flexibility. I represented the system as a circle divided into twelve main sections with 1940 at the centre. The only two conventional chronological sequences were at the centre. All other sequences radiate out from or vector into that hub. In my view this adds narratives and carries more information on a much sturdier structure.

Michael Moorcock
9th Sept 06
PARIS

This creates intersecting and additional implied narratives. my intention being, of course, to try to represent the complexity of a major city.

The sections are divided by approximate word count into 3/6/ 9 and 12

Rivane + Sérgio Neuenschwander Non-Euclidean Episodes

$$\frac{\text{benefit} - \text{cost}}{\text{commitment}} = \text{efficiency}$$

If the costs are zero/less than zero and the commitment close to zero, efficiency becomes almost endless.

In political reform it is expected that costs will be smaller than benefits. Because the actual benefits cannot be sufficiently predetermined, in order to be sure, all expenses have to be compensated by immediate revenue or savings. In politics, anything that costs nothing is not taken seriously. Things that cost nothing require – so it is expected – a great deal of idealism: strong commitment from many people over an unforeseeable period of time. This requires what is called a 'better person'. Where should such a person come from, if not from the results of implemented reform? Until this time, short periods of commitment from fewer people will have to suffice. The best scenario is for them to enjoy themselves. Then the efficiency of their actions is infinite.

For the application of the Law of Reconstruction, see Ingo Niermann, *Umbauland: Zehn deutsche Visionen.*

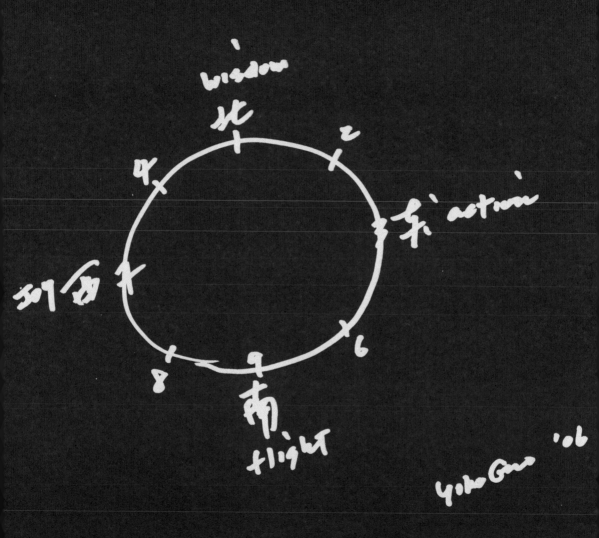

Dans le livre " VIVRE A L'OBLIQUE " réédition de 1970
vous trouverez tout ce qui peut vous intéresser.
J'insiste sur

 LA TACTILITÉ p 35

 HISSER L'HABITATION à la DIMENSION DU SITE p57

 FLUIDITÉ p. 59

 LA GRANDE ACCUSÉE C'EST L'INDUSTRIE p 69

 ÎLE EN TERRE FERME / p 65

 REPULSIVE p 65

 SOL A VIVRE p 43.

Dans le livre " Architecture Principe " de 1966
réédité en anglais en 1996 vous trouverez tout
ce que vous voulez comme :

NOTRE PREMIER SIGLE ; le plan de l'Eglise
de Nevers que nous avions peint sur ma
JEEP militaire américaine que je conduisais
(avant ma Rolls) et sur le capot à la place
de l'étoile USA.

en n°3 d'avril 66 vous trouverez sur " LE POPENTIALISME
en page 2 la formule de P. VIRILIO.

 vertical

Horizontal | = +

 oblique = X multiplication

 oblique

vient reçu signe permanent
de mon papier à lettre

120

Viennent donc les formules qui disent les EXIGENCES
de l'OBLIQUE :

Hypothèse de la "Fonction Oblique" 1964.

– l'ordre oblique détruit l'ordre orthogonal.

– la circulation habitable

– l'obstacle surmontable

– la potentialité du poids du corps

– Instabilité

– continuité

L'architecture doit s'inscrire non plus :
 EN TERMES d'ESPACE (espace du dehors
 espace du dedans

mais EN TERMES de SURFACES
 (surface du dessus, surface du dessous)
 et admettre le RENVERSEMENT des SURFACES

Il ne reste une formule très récente à laquelle
je tiens particulièrement, sur l'architecture,
l'urbanisme et l'aménagement du territoire :
 L'ARCHITECTURE D'UNE ECOLE
 IMPORTE MOINS QUE LA QUALITÉ et !
LA NATURE DU CHEMIN QUI CONDUIT A L'ECOLE

autre formule CLÉ : ECHAPPER AU SYSTÈME.

Philippe Parreno

- YOU HAVE TO PLAY THE
GAME IN ORDER TO KNOW
WHY YOU PLAY THE
GAME.

- HOW

IT'S ALL ABOUT ROLLING OFF A
A CLIFF. KEEP RUNNING WITHOUT WILL
EVER LOOKING DOWN. GRAVITY HAS NO EFFECT

IT'S ALL ABOUT RUNNING OFF A CLIFF
IF YOU KEEP RUNNING WITHOUT EVER
LOOKING DOWN GRAVITY WILL HAVE
NO EFFECT. YOU CAN'T STOP.

Adam Phillips

We know something is new when we have recovered something in the discovery.

We know something is new when we have lost something in the discovery – the possibility of absolute novelty.

We know something is new because it is something renewed.

We know something is new because it is something renewable.

We know something is new when it is not what we expected but what we were looking for.

We know something is new when it is exactly what we expected but not what we were looking for.

We know something is new when we have found something that we didn't know was waiting for us.

We know something is new when we have found something we didn't know we were waiting for.

We know something is new because it changes our idea of the new.

We know something is new because it is a reassuring surprise.

We know something is new when it changes the past.

We know something is new when it keeps the future in place.

John Pickering

Inverting a cylinder with respect to a point on the cylinder produces a cyclide. This cyclide is then reflected and rotated to give three cyclides which intersect one another. Inverting a second cylinder, with respect to a point lying on it, gives another cyclide, which takes up a fourth position.

INVERSION

Inversion in a plane is a transformation mapping all points inside a circle to points outside the circle and vice versa. The centre of the circle is a special point where all points at infinity map. In space, the mapping is of points inside and outside of a sphere.

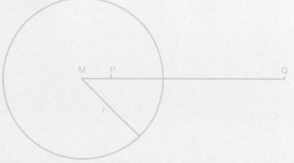

Point P maps to Point Q using the rule $MP \cdot MQ = r^2$

Huang Yong Ping American Kitchen and Chinese Cockroach, 1960–2006

During the National American Exhibition
in Moscow in 1960, the vice-president of
America, Richard Nixon, and the Soviet premier,
Khrushchev, had the 'Kitchen Debate'. In 2006,
circumstances have changed with the passage
of time: the 'American kitchen' is part of daily
life in China, and the Chinese cockroach has
entered the American kitchen.

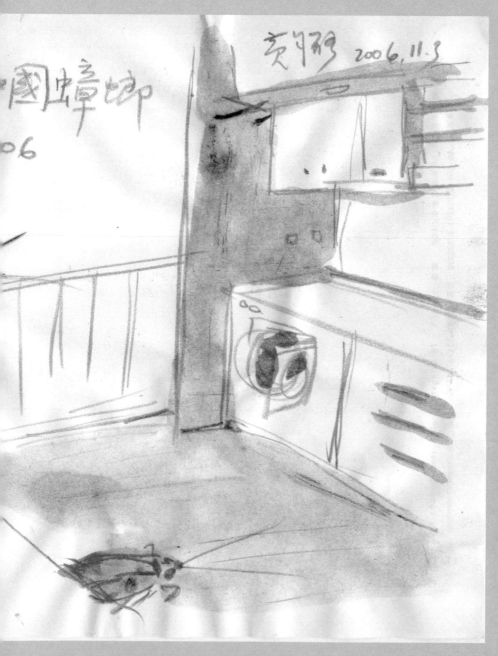

The subtraction of the infinite disquiet of the multitude from the reverberation of the voice of authority by the accumulation of its own echoes, especially when those echoes are heard raised to an exponential power, is equal to anacoustic reason.

The net effect of the disquiet of the multitude can be arrived at by considering the difference between the frequency of the voice of authority and the accumulated voices of the multitude.

Randomness can be taken to imply anything from a sudden and inexplicable outbreak of joy in generally sullen populations to the occasional exhaustion of the mighty; or even the consequences of wear and tear, maintenance and accidental malfunctions in the apparatus of power. In the end, it all adds up to something that has the potential to change the rules of the game. The equation is necessarily fragile.

A careful observation of the fluctuating index of anacoustic reason can yield a precise measure of who and what gets a hearing in the world.

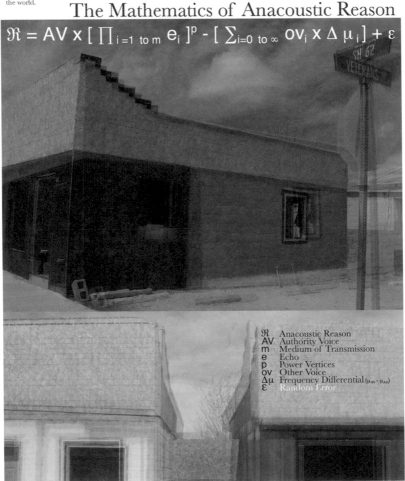

The Mathematics of Anacoustic Reason

$$\Re = AV \times \left[\prod_{i=1 \text{ to } m} e_i \right]^p - \left[\sum_{i=0 \text{ to } \infty} ov_i \times \Delta \mu_i \right] + \varepsilon$$

\Re	Anacoustic Reason
AV	Authority Voice
m	Medium of Transmission
e	Echo
p	Power Vertices
ov	Other Voice
$\Delta\mu$	Frequency Differential $(\mu_{ov} - \mu_{AV})$
ε	Random Error

Pedro Reyes

DEAREST HANS ULRICH, I'VE BEEN LIKE AN OSTRICH, HIDING! BECAUSE I AM STILL SEARCHING FOR THE FORMULA....

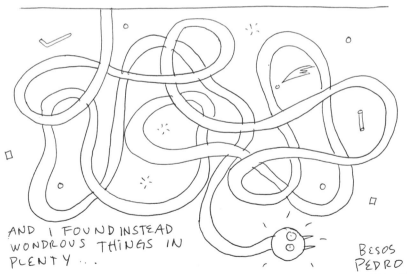

AND I FOUND INSTEAD WONDROUS THINGS IN PLENTY...

BESOS PEDRO N.Y. 07

Gerhard Richter

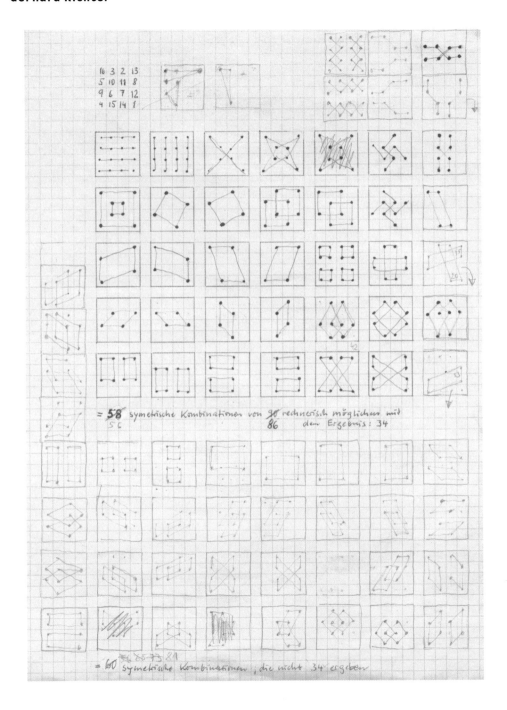

16 3 2 13
5 10 11 8
9 6 7 12
4 15 14 1

= **58** symetrische Kombinationen von 90 rechnerisch möglichen mit
56 86 dem Ergebnis: 34

= 60 symetrische Kombinationen, die nicht 34 ergeben

Matthew Ronay The darker the berry the sweeter the juice

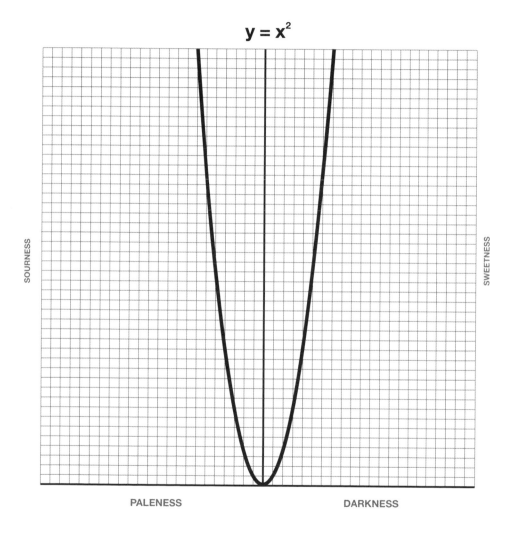

$$y = x^2$$

SOURNESS

SWEETNESS

PALENESS

DARKNESS

The darker the berry is the sweeter and more true the juice becomes is explained here
in the formula y = x² in which y is the sweetness and x is the darkness

Martha Rosler

spooky

action at a distance (entanglement)

and the paradox of

schrödinger's cat,

my favorite of all scientific (physical) hypotheses,

proving once again that

everything we think we know is absolutely unknowable

and/or just plain incorrect.

Anri Sala The cricket formula and a simple formula
for the end of the world

The cricket formula is a formula for calculating what the
temperature is (in Fahrenheit) by measuring how fast the crickets
are chirping.

$$F = {}^{n}\!/4 + 40$$

where n *stands for the number of chirps per minute and* F
stands for the temperature in degrees F.

Using the cricket formula as a starting point, a new formula is
derived. The new formula indicates the extra number of cricket
chirps for every extra degree in climate changes due to global
warming, like an inconvenient sound formula.

$$\Delta \text{ chirps} = 4 \, \Delta F$$

where Δ *stands for 'the change in' or 'the difference in'.*

[1] *The new formula has been calculated by Gregory Chaitin.*

Tomas Saraceno

...HERE A SKETCH FROM THE MEMORY OF A CHILDREN BOOK... TODAY MORE THAN EVER IN "WE ARE THE WEB" BY K. KELLY "A NEW KIND OF PARTICIPATING UNLEASHED BY HYPERLINKS ...ARE CREATING A NEW TYPE OF THINKING - PART HUMAN AND PART MACHINE - FOUND NOWHERE ELSE ON THE PLANET OR HISTORY.... WITH 600 BILLIONS WEBS, ... WHERE 60% OF THE WEB IS COMERCIAL... THE REST RUNS ON DUTY OR PASSION...

BUT WHAT HAPPENED WHEN EVERYONE IS UPLOADING FAR MORE THAT THEY DOWNLOAD? IF EVERYONE IS BUSY MAKING, ALTERING, MIXING AND MASHING. WHO WILL HAVE TIME TO SIT BACK AND VEG OUT? WHO WILL BE A CONSUMER?.... NO ONE. AND THAT'S FINE. A WORLD WHERE PRODUCTION OUTSPACE CONSUMPTION SHOULD NOT BE SUSTAINABLE ... WHERE MANY IDEAS THAT DON'T WORK IN THEORY SUCCEEDED IN PRACTICE, THE AUDIENCE INCREASINGLY & DOES NOT MATTER. WHAT MATTERS IS THE NETWORK OF SOCIAL CREATION, THE COMUNITY OF COLLABORATIVE INTERACTION... THE PRODUCERS ARE THE AUDIENCE, THE ACT OF MAKING IS THE ACT OF WATCHING, AND EVERY LINK IS BOTH A POINT OF DEPARQUE AND A DESTINATION... FROM THIS EMBRYONIC NEURAL NET WAS BORN A COLLABORATIVE INTERFACE FOR OUR CIVILIZATION; A SENSING, COGNITIVE DEVICE WITH POWER THAT EXCEEDED ANY PREVIOUS INVENTION... THAT'S NOT THE BEST FORMULA?... TO BE ABLE TO LIVE IT FREE OF CHARGE FOR USING IT, LIKE AN AIR-SHIP, EARTH-FISH... IN A SYNERGETIC BREATHING, ... FROM BOTTOM TO UP WILL LIFT US......

Peter Saville

Art ⟶ Ready-made

RAPID CITY

Gino Segre

$$\text{Art} = \text{Beauty}$$

$$\text{Science} = \text{Beauty}$$

$$\frac{\text{Art}}{\text{Sci}}* \quad \text{is the Limit}$$

*indeed the Sci's the Limit

Josh Smith

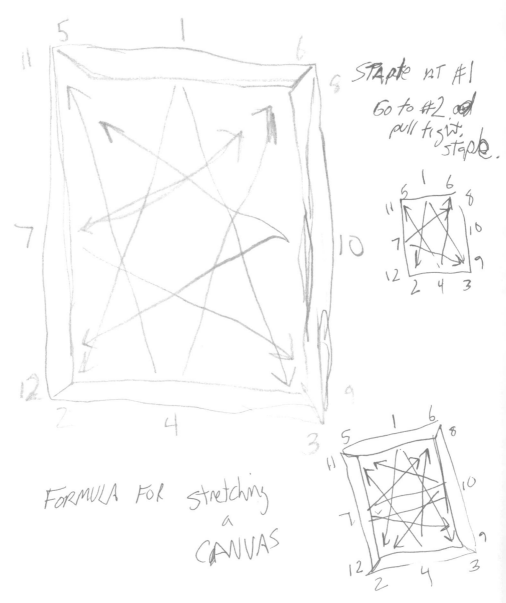

FORMULA FOR stretching
a
CANVAS

STAPLE AT #1
Go to #2 and
pull tight,
staple.

Nancy Spero Formula for the 21st century

The one main thing is that no one (or) no one shall (to be decided) does (or) do anything that would be detrimental to society either physically or mentally. There will be a huge number of scientists and psychiatrists that would monitor the world and Hans Ulrich would be Head Monitorist.

There has to be a Worldwide and Space University in which investigations of humankind's spirit will be done. (In Western Europe – as far as I know and have heard – the number of young people is diminishing and people are living longer and these projects of Hans Ulrich's are the perfect antidote for keeping everybody out of trouble.)

AND WHO WILL WATCH HANS ULRICH?

Karlheinz Stockhausen

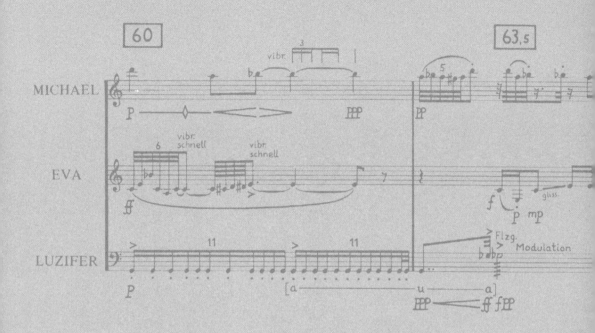

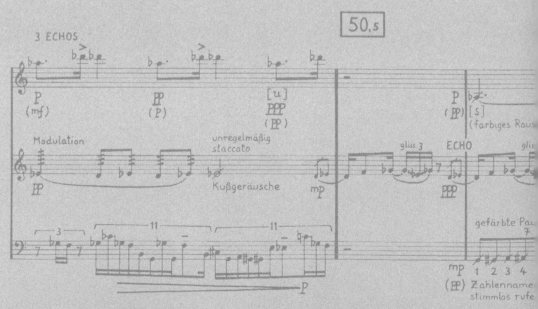

Superformel für LICHT

(Super formula for LIGHT)

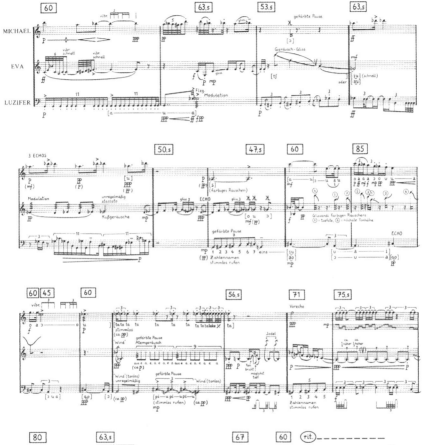

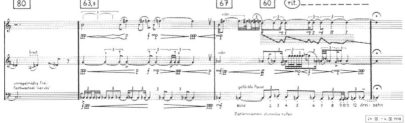

gefärbte Pause / coloured pause; vibr. schnell / fast vibrato; Geräusch-Gliss. / rushing-noise glissando; oder / or; (schnell) / (fast);
farbigen Rauschen / coloured noise; unregelmäßig staccato / irregular staccato; Kußgeräusche / kissing-noises;
Glissandi farbigen Rauschens ①= tiefste, ⑥= höchste Tonhöhe / glissandi of coloured noise ①= lowest, ⑥= highest pitch;
Zahlennamen stimmlos rufen / voicelessly call numbers; stimmlos / voiceless; Vorecho / pre-echo; Atemgeräusch / breathing noise; aus e. a. / exhale inhale exhale;
Ton bricht / note breaks; möglichst tief / as low as possible; Jodel / yodel; ca. ¼ Ton höher / circa ¼ tone higher; 'Wind' (tonlos) unregelmäßig / "wind" (toneless) irregular;
(stimmlos rufen) / (voicelessly call); breit / broad; unregelmäßig frei: Farbwechsel 'nervös' / irregular, free: "nervous" timbre changes.

Desire + Attention =

Expansion

Linda Stone

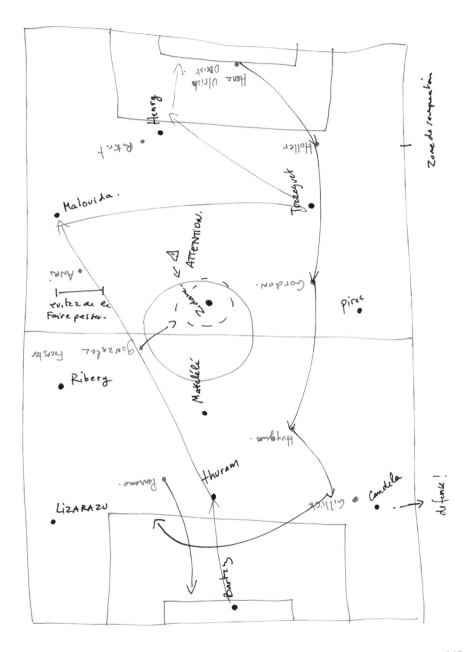

Rosemarie Trockel

to H.V.O.
from RT

$$\left(\frac{\text{Nothing} \times \text{Nowhere}}{\text{Never}} \right) + \text{Nobody}^{\text{None}}$$

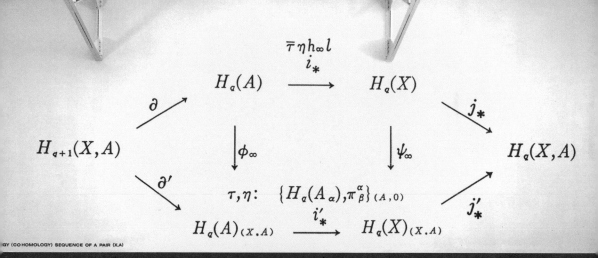

These paintings are related to those I did in the 60s. My objectives are different now, although these paintings share themes I took from books on mathematics. My new paintings are free of the constraints I imposed on myself at one time, i.e., an austerity focused exclusively on theoretical thought. Today, I have much more freedom in my choice of subjects. I select them for their originality, for their remoteness, on the visual level, from anything, as far as I know, that other artists have ever painted. Formally, these are very rich subjects. Some people will attempt to justify or make sense of them by comparing them to geometric art. But geometry is not my concern. I'm aiming at a level of abstraction in this work that is different from anything we've known before. It leaves formalist abstraction behind and enters the field of conceptual abstraction — an abstraction that's

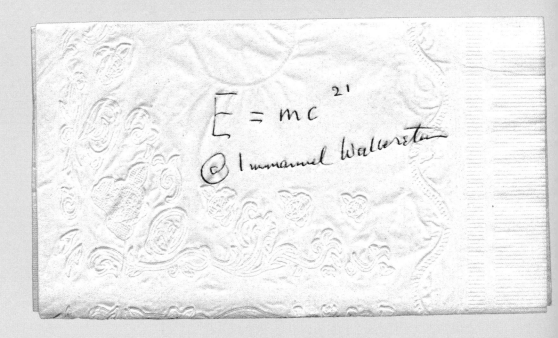

James Watson

A=T
G≡C

J.D.Wats

Ai Weiwei 12 + 1001 = 2008

This is the formula for a project to be completed for Documenta XII, whereby Ai Weiwei
will slice a piece of reality from China and import it wholesale to Kassel.

The **number twelve** refers to this edition of the exhibition, rendered in the hatchmarks
that form its logo.

One thousand and one is written in Chinese numerals, and refers to the number of
Chinese nationals who will be transported to Kassel, where they will live for close to
a month surrounding the opening of the exhibition as part of a massive 'social sculpture',
every material detail of their lives designed by the artist and his team.

Two thousand and eight stands in for the China from which these **one thousand and one**
Chinese hail, in Ai Weiwei's words

'a number whose significance no one quite knows'.

Not yet.

卅 卅II + 壹件零壹 = 2008

十二届
卡塞尔文献展

不带一个人来

有中国

一个不知含义
的数字

一个不可能的可能、另一种现实。

类型

2007-1-29

$$X (N) = X (TO + NT)$$

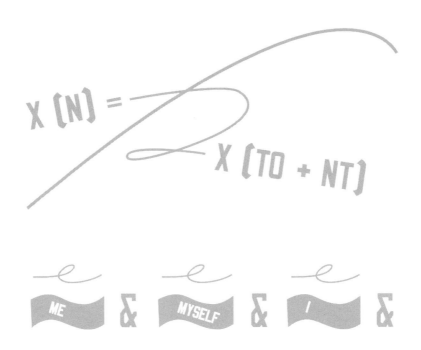

IF IT HAS WORTH ONCE IT SHALL HAPPEN AGAIN

(SUCH IS THE SADNESS OF LIFE)

Richard Wentworth

As a student, I remember a Mancunian joiner who would look at something and say 'racket thigh'. At least this is what it sounded like, but it meant 'reckon it with the eye'.

This of course is the non-formulaic judge-as-you-go approach to life.

I often imagine those great levellers the ancient Egyptians inventing the *wasserwaage* using a bowl of water and a length of twine.

The earliest pragmatists with formalist tendencies.

I remember discovering that **algebra is an Arabic word for mending bones**, assembling parts. If I had been told that at school it would have added a special poetry to something that often resisted me.

The English language is full of poetic contradictions like *'not being able to see the wood for the trees'* which can act as formulae for the way the world obstructs us.

Rule of thumb, as we say, is how we proceed.

A particular favourite, which I have never tested, is that at sea the horizon is always eight miles away, a special sensibility to the geometry of the Earth's typical curvature.

Perhaps Samuel Morse the American artist/inventor knew this when he invented his code mid-Atlantic, on a steam ship.

Franz West Einst Ein (the split nucleus)

the *kern* (seed) in caputh, caputh is kaput, and cannot be put back together again. originally they wanted to install a café in einstein's weekend house in caputh, run by the berlin coffee house café einstein, but einstein the vegetarian, fruit with seeds (*kern*) and fruit with stones (*stein*), brings to mind the slim connection: *ein stein* = *kern* (seed, nucleus); like an atom, the word can be split. the word '*ein st ein*' is two times *ein* with the fricative *st* between them. i have no mathematical training and *ein stein* (a stone) is the first association that comes to mind but a not completely meaningful one, while *einst ein* (first one/originally one) evokes an earlier state of wholeness or oneness, and this oneness can be perceived in its splitness. if albert einstein's name had been albert einistein, the name would have neatly separated into three parts, *ein ist ein* (one is one), but this would have had as little to do with einstein

as *ein stein*. so to me, *einst ein* is the best solution to this undertaking. it also allows for many other associations, for example, with the division of germany.

Addition: ... but *einst* (first) can refer not only to the past but also to the future. a possible earlier fusion is the model for the formation of family names.

Text from *Einstein Spaces*, p. 110 (version above slightly amended)

Addition, 10.5.2007: First *eins* (what was) will become *sein* (fusion).

Stephen Willats

A SOCIALLY INTERACTIVE MODEL OF ART PRACTICE

ARTIST

ARTWORK

AUDIENCE

CONTEXT

Jordan Wolfson

Mario Ybarra, Jr.

5 STEPS TO THINK ABOUT...

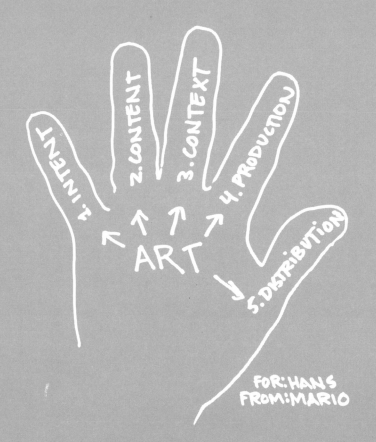

1. INTENT
2. CONTENT
3. CONTEXT
4. PRODUCTION
5. DISTRIBUTION

ART

FOR: HANS
FROM: MARIO

Anton Zeilinger Quantum Entanglement

$$|\psi^-\rangle = \frac{1}{\sqrt{2}}\left\{|1\rangle|0\rangle - |0\rangle|1\rangle\right\}$$

This equation describes
 2 entangled qubits

Quantum Entanglement
 is the Basis of:

- Quantum Cryptography
- Quantum Teleportation
- Quantum Communication
- Quantum Computation

A work-in-progress idea for

the ~~notes~~ picture credits

78 = Loris Gréaud / photograph courtesy Elisa
Pone (still image from Loris Gréaud, Underworks,

(Is this correct?) → 2007–8) + formula courtesy Boutny / Gréaud

110 = Daria Martin / courtesy the artist and Maureen
Paley, London (NO MEDIUM / DIMENSIONS ?)

125 = John Pickering / card + glass mirror, 62 × 57 × 28
photo͡graph by Sue Barr, courtesy AA Publications ↓
24½ × 22½ × 11 inches

147 = Bernar Venet / acrylic wall painting, dimensions
variable site-specific; collection of the artist, France

146 = Keith Tyson / mixed media on aluminium, 61 ×
61 cm (24 × 24 in). HV14492

158 = Anton Zeilinger / photograph ⓒ Jacqueline
Godany

Niki /
Here's my idea for
p160. What if we
print this on graph
paper ? AB

+ 48
 57 colour
105 5 + w
 illustrations